BREAKING THE RULES OF WATERCOLOR

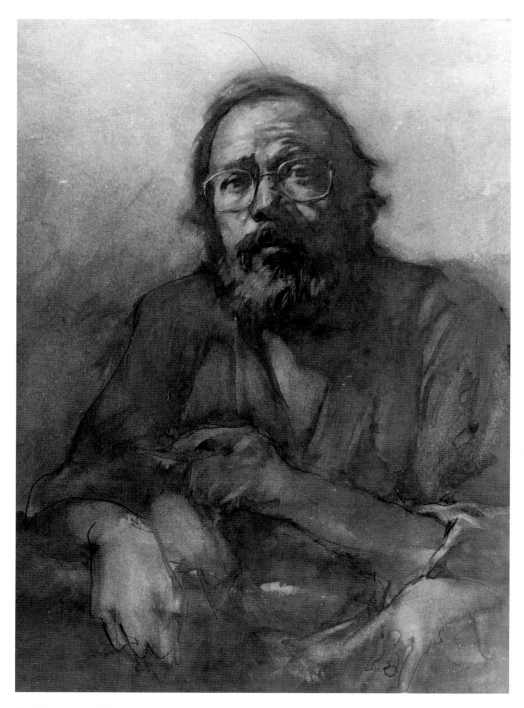

Self Portrait, *1980, watercolor on plate bristol, 14″ x 18″ (35 x 20 cm), collection of Eileen and Richard Gibbs. One of the more difficult things to do is to see ourselves clearly, or as Robert Burns remarked, "as others see us." This is especially true when we paint ourselves. A self-portrait can be the surest route to self-deception or, at the very least, self-flattery. With few exceptions, like Frans Hals, artists usually paint themselves with serious, troubled looks. I suspect that one purpose of this depressive, somber gaze is to promote the idea of the artist-as-tragic-hero. On this defensive note, I hereby present myself.*

BREAKING THE RULES OF WATERCOLOR

BY BURT SILVERMAN

WATSON-GUPTILL PUBLICATIONS/NEW YORK

For Claire, with love.

First published 1983 in New York by Watson-Guptill Publications,
a division of Billboard Publications, Inc.,
1515 Broadway, New York, N.Y. 10036

Library of Congress Cataloging in Publication Data
Silverman, Burt, 1928-
 Breaking the rules of watercolor.
 Includes index.
 1. Water-color painting—Technique. I. Title.
ND2422.S59 1983 751.42'2 82-23779
ISBN 0-8230-0523-2

Distributed in the United Kingdom by Phaidon Press Ltd., Littlegate
House, St. Ebbe's St., Oxford

Manufactured in Japan

First Printing, 1983
1 2 3 4 5 6 7 8 9 10/88 87 86 85 84 83

This book was written over a two-and-one-half-year period and would have been immeasurably more difficult without the patient and thoughtful commentary of my wife, Claire.

My editors were David Lewis, Donald Holden, and Candace Raney. To all of them, I wish to express my sincerest thanks. I am especially grateful to Mr. Holden for his wit and expertise in helping to sort out the most useful material.

I should also like to thank Mr. Philip Desind of Capricorn Galleries for his assistance in locating and photographing some of the paintings.

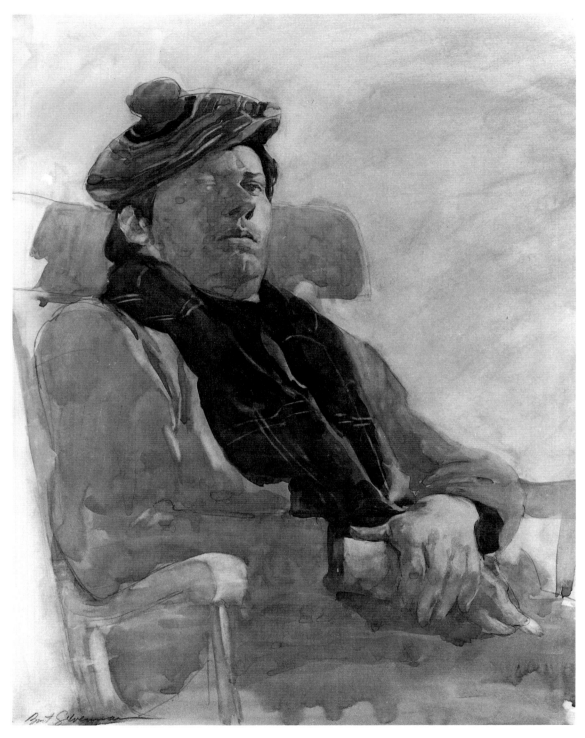

Scotch Plaid, *1979, watercolor on plate bristol, 14½″ x 11″ (37 x 28 cm), collection of Mr. and Mrs. George Brady. This is one of the few paintings about which I had no serious misgivings when I saw it later. It's a portrait that simply clicked and matched my mood. The colors are all muted grays, pinks, and blues, with the exception of brighter tones in the cap and the scarf. The hands gave me the most trouble—as they often do—perhaps because I frequently do them last. I put a lot of effort into those hands, painting and repainting them, because I thought that they were particularly important to the content of the painting.*

Contents

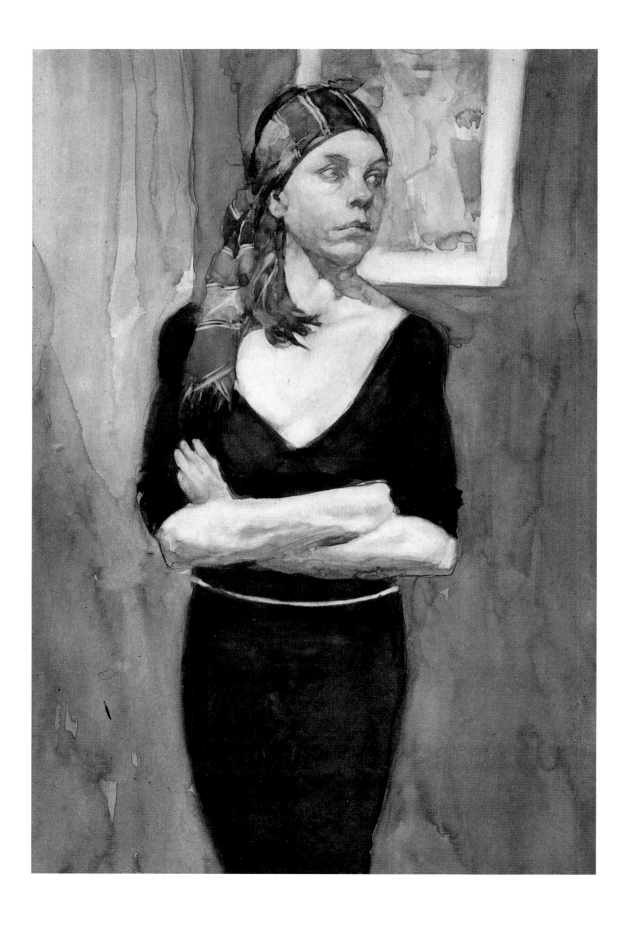

Introduction

As you'll discover shortly, my methods of painting a watercolor—and my attitudes toward the medium—are somewhat at odds with the traditional approach that will be familiar to most readers. For many of you, this book will be unorthodox and surprising. But my approach to watercolor is actually consistent with the long history of the medium and is really the logical outgrowth of a long, and sometimes frustrating, search for a personal way of using the medium.

That search wasn't a conscious attempt to develop a special style or an original technique. I was simply searching for a way to free myself from the uncomfortable constrictions of traditional watercolor painting as practiced by most of my contemporaries. My quest grew out of my dissatisfaction with traditional papers and traditional "rules." In essence, my approach to watercolor was born out of the frustration of being unable to paint with the relative ease and abandon of oils. I was trying to find a way of handling watercolor that was free and flexible enough so that I wasn't afraid to make a mistake! The product of that search was a method that breaks a lot of the "rules" that most watercolorists have been taught to live by.

So then, this book will be an account of my long search for a watercolor method that would be flexible enough to harmonize with my work in other media—oil and pastel—and neutralize my fears of the medium. Among other things, I'll try to reshape some stereotyped attitudes toward watercolor and look at the whole question of technique in the light of history. Along the way, I'll talk about some of the great watercolorists of the past, whose work I looked to for inspiration—and for rescue. And finally, I'll describe how I arrived at a method of using watercolor that permits me to exploit the freshness and spontaneity inherent in the medium, but also to change my mind—to make massive corrections in drawing or composition—and to render an image in very much the same way as I might in oil or pastel.

All this might appear to be startlingly new. Oddly enough, as you'll see, my methods are much closer to those of nineteenth-century artists than to contemporary watercolorists.

I hope that this story—and the methods in this book—will help to demystify watercolor, and also enable you to arrive at a more satisfying way of using the medium. And I hope that the demonstrations will reveal the remarkable versatility and pleasures of the wonderful tool that we call watercolor.

Beginnings

When I started writing this book and assembling the pictures for it, I was surprised to discover that I'd been using watercolor for practically all of my professional life—and for a long time before I ever had any thought of becoming a professional.

I think I was about ten or eleven years old when I got my first watercolor set. I suspect that the set wasn't very different from the kind still available in stationery stores and given to kids in the hope of distracting them from electronic war games and other fad toys. I had no idea of the majesty of the medium, and probably for just that reason, I became an instant enthusiast. Compared to the oils that I'd received earlier, watercolor seemed so easy to use and so much more fun!

I remember painting lots of ships at sea because, at the time, I was fascinated by stories of famous seafarers. I was obsessed by old-time sailing vessels—their history in words and pictures. I think these symbols of the "olden days" were especially attrac-

Dancer with Arms Folded, 1979, watercolor on plate bristol, 20" x 14" (51 x 36 cm), collection of the artist. Like so many of the paintings I do, this one lies somewhere between a portrait and a "poster." I'm particularly fond of this picture because it went smoothly, exploiting the peculiar behavior of watercolor on plate bristol, rather than fighting the medium. I also like the painting because of its simplicity. That is, the picture makes do with a minimum of pictorial cues to establish a voice—an emotional tone—for this passive figure.

tive escapist fantasies for a kid like me who really hated to play center field (I mean *deep* center field) on hot July days.

I can't remember any of the pictures I painted as a child, except for one watercolor that's somehow managed to survive over the years. It's my rendering of the battle between the *Constitution* and the *Guerriere.* I'm sure it was an attempt to emulate one of the many ship paintings that I'd seen in books. The picture is reproduced here as a matter of curiosity.

Discovering the Masters

My interest in paintings of ships led me to art books, where I inevitably came across the works of J. M. W. Turner, one of the most extraordinary artists of the past two hundred years. His watercolors were particularly compelling. One especially engaged my interest. It was titled *A First Rate Taking on Stores* and has lodged in my memory, almost intact, from the moment I saw it. I recall being in love with the exquisite details of the picture, and marveling at the skill of an artist who could paint those details with such perfection. There was also something very affecting in the image, something I couldn't articulate then about the mystery and danger of this awesome vessel. The painting was magic to my untrained eye, and the magic remains for my trained eye today.

The watercolor was a typical Turneresque tour-de-force, painted to satisfy the playful request of an aristocratic patron who wanted to see what an eighteenth-century English ship-of-the-line really looked like. The patron's daughter wrote an extraordinary account of how the picture was produced. I didn't read her letter until I was an adult—long after I first saw the painting in a book—but her letter defines my feelings about what painting in watercolor should really be like.

> He began by pouring wet paint onto the paper until it was saturated. He tore, he scratched, he scrubbed at it in a kind of frenzy and the whole thing was chaos—but gradually, and as if by magic, the lovely ship, with all its exquisite minutiae, came into being . . .

What's left out of her letter, of course, are Turner's years of training along the Thames and at the seaside, where his amazing visual memory had absorbed all that he needed to replicate boats, sea, and sky with such ease.

Looking at the painting as a kid, I knew none of this. Nevertheless, I was aware that this painting, among all the other ship paintings I'd seen, was something special.

Over the course of the next few years—and well beyond—I came across many other kinds of watercolors that began to shape my understanding. As I look back, I find it especially interesting that I never clearly identified these paintings as *watercolors,* at least not until much later.

I discovered Winslow Homer's paintings of boats in New England harbors and his views of the Caribbean. I vividly remember Edward Hopper's crystalline watercolors of strange old houses and moody urban rooftops.

All this began to open my eyes to the wide-ranging pictorial possibilities of paintings—not just watercolors—and to the deceptively simple means that the artist used to achieve his effects. The paintings seemed so effortlessly done. Looking at the broad, simple washes, and the directness of the artist's observation, I was inspired to work in a similar way. After many failed attempts, I discovered that this apparent simplicity was the result of long study and profound understanding. I saw that it was a long, problematic road from external "facts" to the painted image.

Student Days

My naive affection for watercolor was almost destroyed by my first formal training. My high school watercolor courses were dominated by an approach that was very different from the work I liked in this medium. We were told to let the colors run loose, merging wet-in-wet and producing a random, often unpleasant blend of strident colors. It was a conception of painting that drew its inspiration from post-Cézanne modernism—from Kandinsky and Matisse—a kind of painting that was concerned totally with abstract notions of form and color, and it declared the world of visual reality irrelevant. This kind of watercolor painting seemed worlds apart from the grace, energy, and magical light of Turner. And it was equally alien to the direct and gritty realism of Hopper. Forced to exercise my "expressiveness," I almost came to hate the very medium of watercolor!

I continued to use watercolor, but very sporadically, and I must admit that I can't recall any specific work from my early student days. Other things were crowding watercolor out. Oil, pastel, etching, and *always* drawing became the dominant preoccupations of my next several years.

I also suspect that I produced very little work in watercolor because I'd identified watercolor only

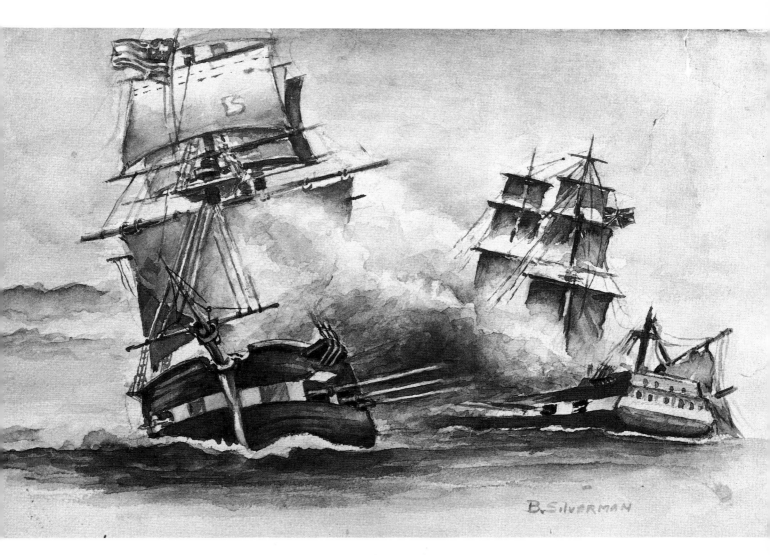

The Constitution and the Guerriere, *ca. 1938, watercolor on cold pressed paper, 10" x 15" (26 x 38 cm), collection of the artist. My memory of having done this watercolor seems more like a dream. As I stare at the picture, I have only some vague sense of having struggled with the rigging of the ships, perhaps because I didn't have the right brush. I'm not exactly sure why, but something suggests that I worked very hard on this favorite subject and that I was pleased with the result. Hence that overly large signature—even for a ten-year-old.*

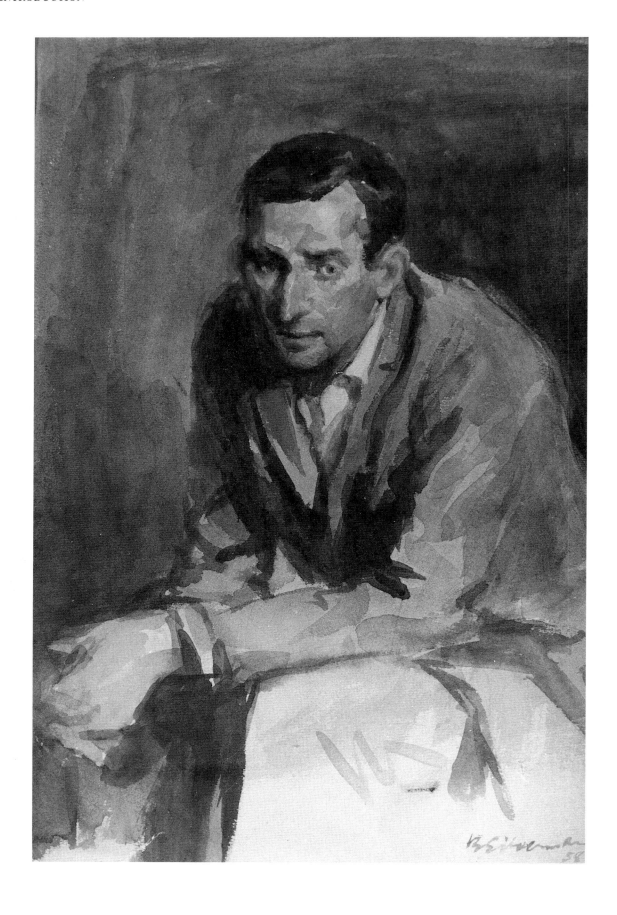

with landscape! I simply hadn't seen any figure paintings in this medium, and my inexperience—or lack of imagination—kept me from seeing the possibilities. On reflection, maybe there was something else: I may have been afraid to try!

When I finally came across John Singer Sargent's watercolors of people in the Brooklyn Museum in the early 1950s, it was a revelation. Here were figure paintings that seemed as affective and powerful as anything done in oil. There was a watercolor called *The Tramp* that especially engaged my interest because of its extraordinary sense of reality and utter simplicity. In addition, the characterization was touching and genuine—very different from many of Sargent's big, commissioned oil portraits.

For a student like me, struggling with problems of buckling paper, clean color, and the "right" kind of brush, this painting was both stunning and provocative. I saw at once that the carefree directness of the picture was actually based on the artist's consummate facility in drawing. It was the sound, classical drawing that underlay the light and dark structure which made the picture so solid, despite the apparent looseness of the artist's brushwork.

I wondered how I could use what I learned from Sargent—his mode of applying the paint—without falling into the trap of imitation. After all, Sargent's style and technique were inseparable from his personal point-of-view, and also inseparable from the viewpoint of his era.

At the time, I had neither the intellectual nor practical experience to see that imitation could actually help me find my way—my *own* way—if my emotional drive and creative gifts were strong enough. Years later, I would read Sir Kenneth Clark's *Rembrandt and the Italian Renaissance*, showing how the great Dutch artist used the compositional studies of Raphael and Titian in his own work. The art historian's point was that art feeds on itself. The artist who's saddled with the "necessity" to be original has to discover on his own that imitation doesn't necessarily lead to mediocrity.

Sometime around 1956, I painted a portrait of a fellow artist and friend, Sheldon Fink. As I looked at the finished watercolor, I realized that I'd had Sargent's painting of *The Tramp* very much in mind. I was dissatisfied with my portrait, and I remember feeling that maybe watercolor wasn't really for me. I felt terribly unsure of myself. The idea that watercolors could become a significant part of my production—despite the splendid examples in the museums—seemed a frail hope. I think I was also influenced by the widespread feeling that watercolor was a kind of "lightweight" medium, unsuitable for extensive explorations of the figure. I adopted the notion that watercolor paintings might serve as "preparations" for more "important" pictures in oil. So, for a while, I continued to use watercolor primarily as a study medium for projected pictures in oil.

Landscapes in Watercolor

In the late 1950's, I began to paint landscapes more often, spurred in part by my association with the artists centered around the Davis Galleries in New York. While I often used oil for outdoor subjects, I began to switch to watercolor for some very practical reasons. Watercolor equipment was lighter and less burdensome to carry around while I was searching for the right subject. Watercolor landscapes could be finished much more quickly than the slow-drying oils. And there were lots of other small factors. For example, stray particles of dust and other debris wouldn't stick to the surface of a watercolor. Nor did I have to worry about smearing a wet oil painting on my trek back to the studio.

Of course, there *were* small disasters, like the time I was painting under the Brooklyn Bridge. As I stepped back from the painting to study in and to look at the scene in front of me more closely, a gust of wind solved my doubts about the painting by sweeping the sheet into the East River. Lesson: keep your paper well taped and well weighted down.

At that time, my painting style reflected a feeling of insecurity about the medium, coupled with a need to get more precision into my watercolors. I began to combine watercolor with pen-and-ink. If I can recall my thinking at the time, I must have felt that the ink lines gave more substance, more definition, and more articulation to the scene. But I suspect that I also didn't quite trust watercolor to do the job all by itself. I was, in fact, retreating to the "safety" of the drawn line to give the picture some strength that it seemed to lack with color alone.

I was also much taken with Rembrandt's pen-and-wash drawings—many of them landscapes—which seemed to suggest the perfect resolution for my failure of confidence in "pure" watercolors.

Portrait of Sheldon Fink, 1958, watercolor on cold-pressed paper, 12" x 16" (31 x 41 cm), collection of the artist. I did several paintings of this fellow artist and long-time friend. I'm afraid that my watercolor doesn't quite get at the truth of this interesting-looking and complex man. I suspect that I was still more concerned with managing the medium than with what I was saying in the picture. I also had Sargent's painting of The Tramp *floating around in my mind's eye—a model of excellence and an inhibition at the same time.*

Two Women, *1960, watercolor and ink on cold-pressed paper, 4″ x 6″ (10 x 15 cm), collection of the artist. In the summer of 1960, David Levine cajoled me into joining him at Coney Island for the start of his perennial summer of painting at the beach. The expedition wasn't particularly productive for me. Nor were one or two successive outings. But these first few attempts did sow the seeds that led to my later involvement with figures at the beach—although the beach turned out to be in Italy, thousands of miles and many years away. This small sketch, watercolor with pen lines, is the only survivor of those first expeditions. It's really more a drawing than a painting. The colors are mostly sepia tones, with a hint of pale blue in the water. The method is characteristic of the kind of watercolors I was doing in the early 1960s.*

I also told myself that I'd use these drawing-paintings back in the studio to paint more ambitious landscapes in oil. But I never did, really. Although I didn't use this line and watercolor combination all the time, I tried it often enough to feel that, somehow or other, I was cheating.

Considering the volume of landscapes that I actually produced during this time—roughly 1958 through 1964—it's clear that I wasn't *totally* deterred from working in this genre. But I was still looking for solutions that evaded me, for some other vocabulary that would satisfy my temperament with respect to landscape painting. I still hadn't found my own "voice." I loved to paint sweeping vistas from rooftops or hilltops overlooking European towns—but I couldn't entirely free myself from the influence of the likes of Turner and Constable. And as I said before in connection with that Sargent portrait, I still didn't know how to integrate the lessons of these artists with my own work.

Victorian Roof, *1961, watercolor and ink on cold-pressed paper, 7″ x 11″ (18 x 28 cm), collection of Mrs. Gloria Kaplan. I painted this picture in the Park Slope section of Brooklyn, very close to my studio. Living with tall buildings all around me, and rarely with a view of the distance, I suppose I was impelled to seek the rooftops of this urban landscape to capture the kind of "townscape" that was more common to past generations of landscape painters, particularly in the nineteenth century. I was also attracted by the interesting forms of this building's early architectural style, which I found more appealing than the drab boxes of contemporary structures. The subject also dovetailed with my use of pen and ink because the shapes gave me something to draw! Nevertheless, I also felt it important to locate this old building in the contemporary world. Hence the distant skyscrapers and the billboard on the right.*

Ashland Coal, *1960, watercolor and ink on cold-pressed paper, 10″ x 14″ (25 x 36 cm), collection of the artist. During this period, I was doing a great deal of landscape painting and began to favor watercolor more and more because of its portability and because it allowed me to bring back a "finished" piece nearly all the time. The pen-and-ink line was my security blanket—a way of helping me make the transition from the security of drawing to the more ambitious medium of painting. At the same time, I was emulating the seventeenth-century Dutch artists who used pen-and-wash in their landscape drawings. The setting of this picture was a fascinating combination of industrial wasteland and working class residential area called the Gowanus Canal in Brooklyn. Over the course of that year, I did many pictures on this spot.*

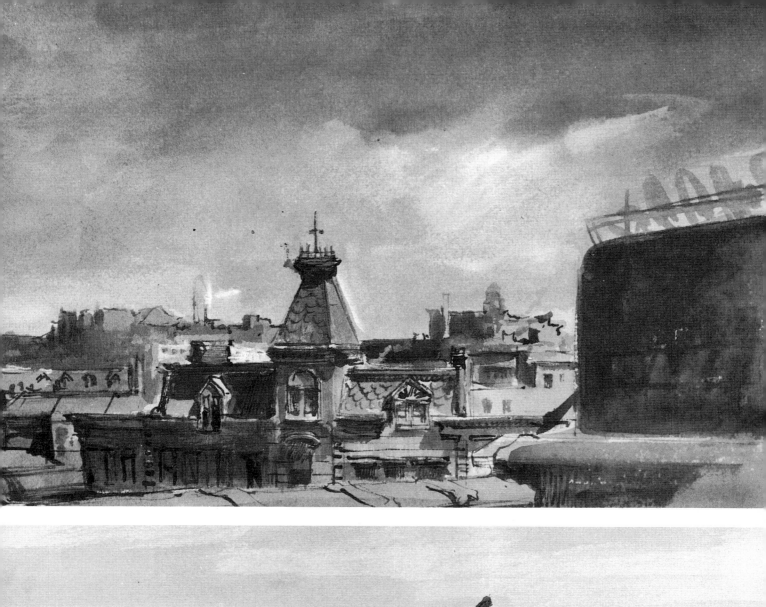

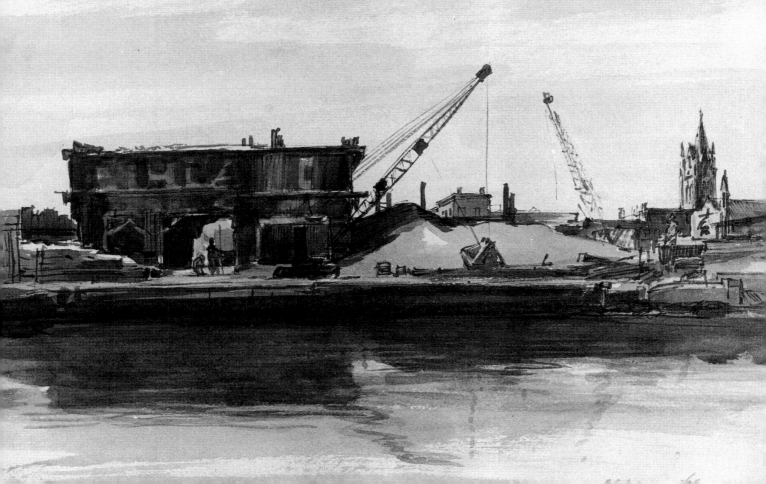

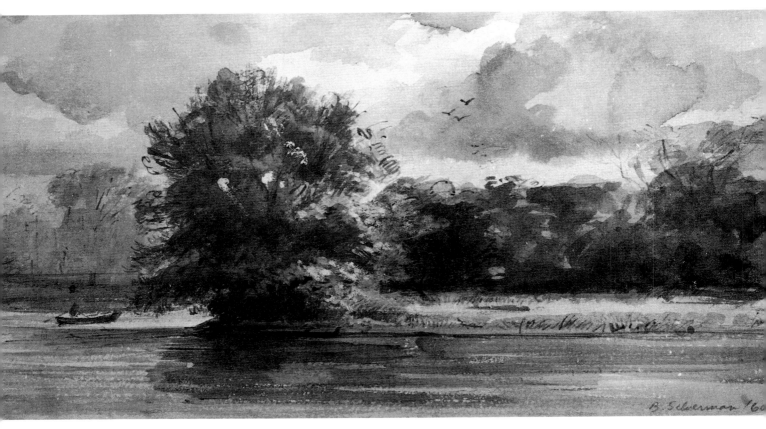

In Prospect Park, *1960, watercolor and ink on cold-pressed paper, 7″ x 13″ (18 x 33 cm), collection of Rosalyn and Gordon Silverman. Prospect Park in Brooklyn became another one of my favorite haunts for more traditional landscapes that were otherwise unavailable to the city dweller. This painting of trees at the water's edge reflects my continuing infatuation with Rembrandt's drawings. The pen lines are helpful, but unobtrusive. The painting doesn't ignore the potential of watercolor itself, which plays a significant role in the textures of the water and the sky. I also think I've caught the character of the light, showing the sudden shifts from sun to cloud that always seem to dog me when I paint outdoors.*

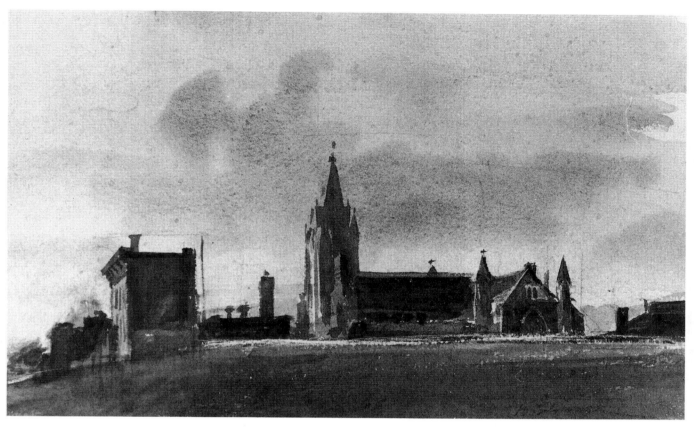

Another Look at the Masters

In the summer of 1962, I went on another long trip to Europe, and I took my watercolor equipment with me, as usual. I was also eager to see Constable's work once again. At the Victoria and Albert Museum in London, I stumbled across a group of British watercolor masters who were largely unknown to me—and probably unknown to most other artists outside the United Kingdom. The group included such names as John Sell Cotman, Thomas Girtin, John Crome, and David Cox. While some of them worked in oil, they were essentially watercolorists and produced exquisite paintings of the rolling grace of the English countryside. Their names have become more familiar today, but they're still relatively unknown, and their role as forerunners to the later achievements of Constable and Turner go largely unacknowledged outside Britain.

Looking at these small sheets of paper, I was struck once again by the power of watercolor to evoke a rich complex of natural forms—sweeping vistas of rolling hills and trees, ever-changing skies, Gothic architecture, all bathed in wonderfully lucid color and light. Studying Girtin's landscapes, I saw that one could articulate the exquisite details of a vista with-

A Church in Brooklyn, 1962, watercolor on cold-pressed paper, 7½ x 12¼" (19 x 32 cm), collection of the artist. Here's one of the few landscapes that I executed in pure watercolor during this period. It's a favorite of mine, perhaps because it seems free of dependence on the pen stroke, and consequently free of the suggestion of an older style. The grain of the paper was still a persistent problem, as it was with my other watercolor landscapes, and I fretted more and more about this. I did some scraping with a razor blade on the streak of light just under the church. I remember that the sky was fun because I floated a wisp of blue-gray cloud onto a partially dry, pale yellow ground—and I found that it really worked!

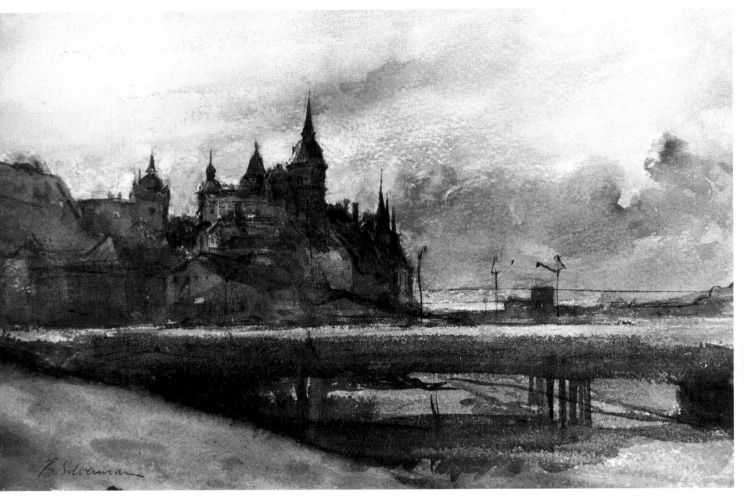

The Old Town, Stockholm, *1964, watercolor on cold-pressed paper, 9″ x 14″ (23 x 36 cm), collection of the artist. This painting was one of a group of landscapes I did after my "discoveries" at the British Museum. The picture is part Bonington, part Turner, but not really either of them. It's really a picture out of my childhood, when I was awash with romantic fantasies. The adult in me took this wonderful, "picturesque" view of Old Stockholm and then located it in the present by choosing a vantage point that included a modern, elevated roadway—instead of the drawbridge that would have been obligatory in the time of King Arthur.*

out using the pen-and-ink. Cotman showed me how it was possible to build forms and create space and light through the systematic overlay of colors, flat shapes laid one over the other like translucent sheets of colored glass.

For the moment, the impact of these English watercolorists was exhilarating and spurred me to paint landscapes throughout the subsequent weeks of the trip. But after this trip, I found that I painted fewer and fewer landscapes. My mind was on faces and figures.

However, I was still an indefatigable "museum rat," as Raphael Soyer once put it, and I continued to search out and study wonderful examples of painting on my trips abroad.

It was on a visit to London in 1964 that I discovered the brilliant French townscapes of Richard Parkes Bonington, and the elegant landscapes and coastal scenes of Peter de Wint. But it was in the print room of the British Museum that I really struck gold. For here, as in the Victoria and Albert Museum, I could examine, out of the frame and in my own

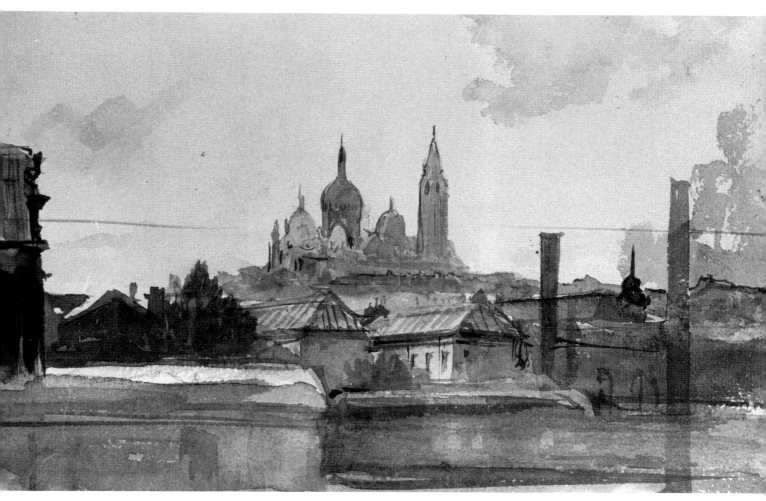

hands, the middle and late watercolors of Turner. Although they were almost entirely landscapes and seascapes, they were my most decisive lesson in watercolor—and art in general—suggesting how I might use the medium more successfully.

What I saw was an amazing fusion of abstraction with precise observation of nature. In these watercolors, I saw how Turner began each painting with abstract shapes and colors, and then gradually built a finished rendering of the form with ever-deepening combinations of pure color and more precise brushwork. No matter how much the artist simplified form and color, the final painting was always strongly connected to visual reality—what Turner actually saw or remembered. As John Ruskin, Turner's ardent supporter, wrote: "Turner's merit . . . consists in this, that, from his tenth year to his seventieth, he never passed a day and seldom an hour, without obtaining the accurate knowledge of some great natural fact; and never forgetting anything he once knew, he keeps expressing this enormous accumulated knowledge."

Sacre Coeur from the Gare du Nord, 1962, watercolor on cold-pressed paper, 6″ x 9″ (15 x 23 cm), collection of the artist. This small painting was done in a bound sketchbook, containing watercolor paper on which I recorded some of the places I visited on my European trip in 1962. In the museums of Paris, I had seen much that was exquisite and moving, especially in the small museum called the Jeu de Paume, which housed, among others, the paintings of Corot and the Barbizon painters of the late nineteenth century. (Now this museum has been reorganized and functions as the great French collection of the impressionist painters.) I was overwhelmed by Paris itself, and could find nothing to paint that didn't seem merely picturesque. Waiting for a train to take me south to Lyons, I caught sight of the Cathedral of Sacre Coeur, the subject of so many tedious renderings by street painters, perched atop a foreground row of featureless industrial buildings. The cloudy sky added to the effect by throwing uneven light across the panorama of buildings, from which the church rose like a ghost out of the past. The colors are mostly blue-grays and shades of umber.

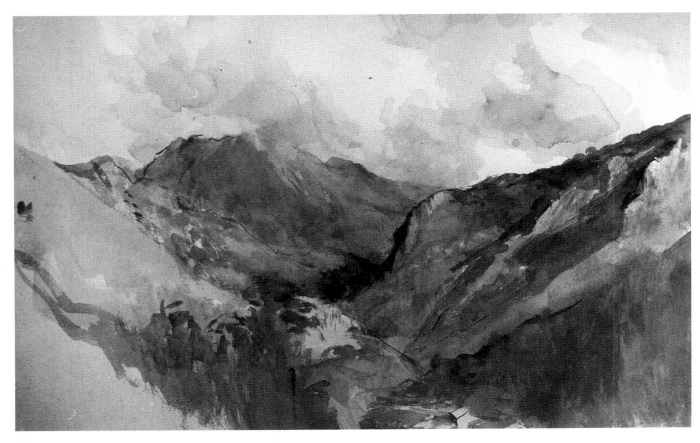

Holding those Turner watercolors in my hands, I also became aware of the amazing flexibility of the artist's technical means. This greatest of all water-colorists seemed totally unaware of the "rules" that I'd learned about watercolor. He didn't hesitate to wash out, scrub out, scratch out, and repaint until he got it right. He'd obviously never heard anyone say that transparent watercolor was, for some reason, better than opaque watercolor, and he combined transparent, semitransparent, and opaque passages with complete abandon. In short, he used watercolor with a freedom that I'd never seen before, building up a picture, wiping it away, and building it up again with an ease that I thought was possible only in oil.

Looking at Turner—and other artists as well—I began to find the answers to some philosophical questions, as well as technical ones. What I came to understand was that realism was an enormously flexible and constantly changing *attitude*, not just a style. The vast panorama of paintings that unfolded before me in the museums reenforced, more than ever, my understanding that the visual world was *not* just one thing. It was constantly being reconstructed by the perceptions of artists. And for each change in perception, there was a change in style, a change in touch, a change in technique.

(above) **Near Monteggiore,** *1962, watercolor on hot-pressed paper, 11″ x 18″ (28 x 46 cm), collection of the artist. This picture, done while I was still painting on traditional papers, is a reminder of some of the frustrations of painting landscapes. I came upon this view in the early morning, but I was unable to return to it for several hours. When I was finally set up to paint, the sun had changed and almost everything provocative in the scene had evaporated. Out of sheer obstinacy, I suppose, I painted it anyway.*

(right) **Under the Brooklyn Bridge,** *1964, watercolor on cold-pressed paper, 11″ x 15″ (28 x 38 cm), collection of Rosalyn and Gordon Silverman. For a brief period, I tried to work on thick, strongly textured paper. This landscape is typical of the results. The grainy texture nearly did me in! It seemed like an achievement just to get the pigment to move around on the surface of the paper. Despite this apparent resistance, the painting turned out more successfully than I thought. It does have a distinct mood. Even after twenty years, I think the picture succeeds in projecting a gloomy sense of the isolation and anomie of the urban experience.*

Struggling with Watercolor

Throughout these years of struggling with water-color, there were always some troubling technical issues that I could never deal with to my satisfaction. The biggest problem was paper.

Looking at the work of the old masters of water-color, I could see that their papers were relatively smooth and lightweight—the kind of paper that usually buckles when wet—but I couldn't see any adverse effects that might have been produced by working on a wet, rippled surface. These wonderful British painters seemed to have perfect control over their washes and had no apparent difficulty when they changed their minds, wiped out a passage, and then started again. Although their paper seemed smooth and flimsy by our standard, the paintings done on these papers had a technical richness and a degree of finish that was beyond me—and beyond most of my contemporaries.

In my own experience, my first washes buckled my paper and prevented the second and third washes from being applied smoothly. To offset this problem, I tried using a heavy, rough paper that warped less than the lighter variety. Aside from the annoyance of having to tape down the edges of the sheet and waiting for the paper to dry thoroughly, I was also frustrated by the insistent texture of the painting surface.

But another, more troubling issue—also tied into the whole question of papers—was the problem of making changes in the painting. How could I correct a bit of bad drawing or retrieve white areas that had received too much color? If I caught the error in time—before the color had dried—I could blot or gently rub out that section of the picture. However, this was difficult to do on the heavy, textured paper that was the standard watercolor stock. Because it was so difficult to make these changes in the course of the painting, I felt that watercolor couldn't give me

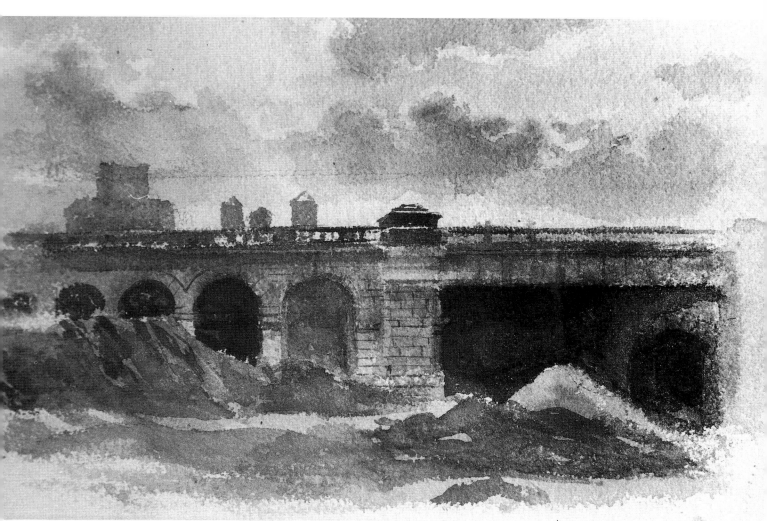

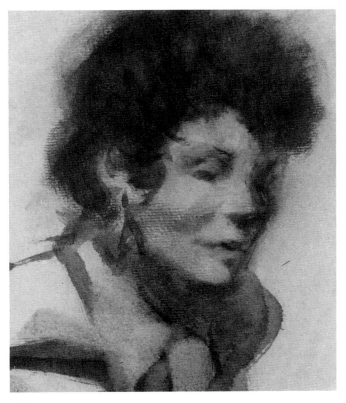

(left) ***Claire Dancing*** *(detail). This closeup shows the characteristic look of oil paint, thinned to a wash with turpentine, then brushed onto watercolor paper. The paint looks and behaves almost like watercolor, but not quite. The strokes tend to "bleed" a little and the hair has a scrubby look that's close to—but not quite the same as—drybrush.*

(below) ***Claire Dancing,*** *1968, oil wash on cold-pressed paper, 22" x 32" (56 x 81 cm), private collection. These three figure studies were done with sepia oil color, thinned to liquid washes with turpentine, so the color handled like watercolor. The drawings were intended as studies for a series of paintings I was doing on the new dance that emerged with big beat disco music. Working with washes of oil paint—which I could rub out with turps to create lights or eliminate errant lines—led me to thinking that I could try the same thing with watercolor. Such oil wash drawings work best on a treated surface—a surface that's been made less absorbent by a thin coat of gesso or highly diluted shellac. My next step would be to attempt the same thing with watercolor on a tough, gesso-coated, relatively nonabsorbent surface.*

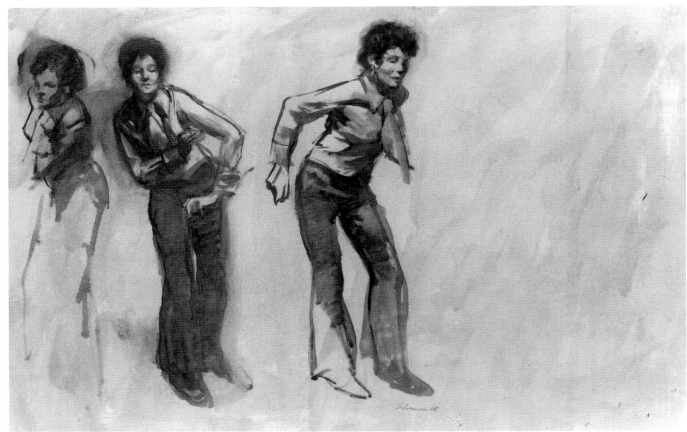

the kind of flexibility that was available in media like oil and pastel. I felt frustrated by the need to plan the painting so carefully in advance and follow a step-by-step method of attack, with so little leeway to change direction, improvise, or simply grope my way, as I often did in an oil painting or a pastel.

The paintings I'd admired in the museums seemed immune to these difficulties. And this constant impediment would ultimately lead me to search for a different kind of paper to paint on.

For a while, in the 1960s, I simply put aside these annoying issues and more or less stopped doing watercolors. At the time, I was most involved in figure painting in oil and pastel. I told myself that I'd face up to my watercolor problems at some future time.

That time came a lot sooner than I anticipated. Toward the end of 1967, I was preparing some small paper "panels" for making oil sketches. I simply sized the surface of a 100 percent rag illustration board with acrylic gesso to isolate the fibers from the corrosive action of the linseed oil in the oil paint. These durable, lightweight panels were very pleasant to paint on. It suddenly occurred to me that something like this surface might also take watercolor, which wouldn't be absorbed in the same way that untreated paper soaked up the color. Conceivably, I could wipe out unwanted passages of watercolor and get back to a clean, white sheet without any damage to the fibers. At this time, I was also painting with turpentine washes—just a little oil paint and a lot of solvent—on shellac-coated paper, and wiping out the lights. Perhaps I could do the same thing with watercolor on gesso-coated board.

Suddenly, there seemed to be a remedy for all my watercolor problems and insecurities if I could simply wipe out the color to make changes or correct my drawing. I tried making several small panels of Whatman board (no longer available, alas), each with a different number of gesso coats. I tried sanding some of the panels a great deal, others only slightly. At first, the results seemed terrific!

But I soon discovered that the surface was terribly quixotic. Sometimes the paint went on beautifully, with all the fluid feeling that makes watercolor such a unique medium. At other times, my brushwork looked crabby and jagged. And some dye colors stained the gesso, such as alizarin crimson, Prussian blue, and viridian. But I put aside these difficulties and kept going because I felt that I was finding a means of using watercolor to paint my figure compositions. Besides, my working habits were often erratic anyhow.

I used these gesso panels for watercolors for more than five years, and I got some relatively good results.

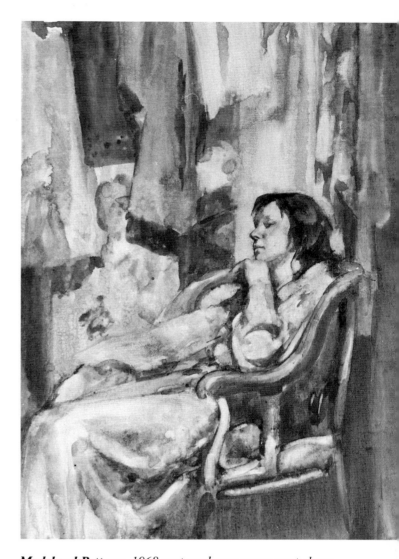

Model and Patterns, *1968, watercolor on gesso-coated rag board, 20" x 14" (51 x 36 cm), collection of Dr. Alfred Tanz. Looking at this picture again after all these years, I remember feeling irritated with the surface, which seemed exceedingly dry and resistant. The pigments all seemed to have a strong tendency to stain, and the paint wouldn't lift easily. I really had to struggle with the picture—and the erratic look of the surface seems to show it. However, despite problems with the materials, the picture isn't all that unattractive.*

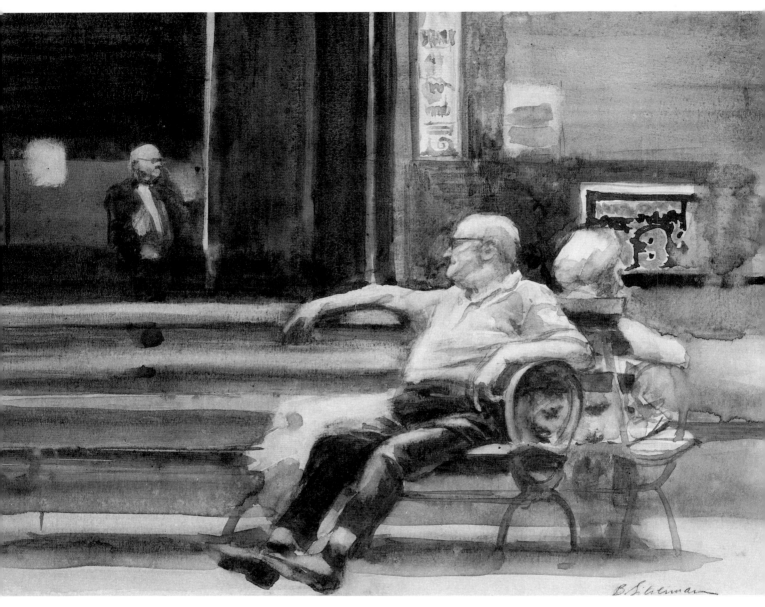

The Benchsitters, *1969, watercolor on gesso-coated rag board, 12″ x 16″ (31 x 41 cm), private collection. This is one of a series of paintings I did for a picture story in* New York *magazine on the people who sat along Broadway on the Upper West Side of Manhattan. Although I painted them from photographs, they still seem rather convincing to me, many years later. Painted on gesso-coated paper, the watercolor tends to form runs, drips, and hard edges that help to give the image a sense of immediacy. Although it would have been easy to do, I don't recall doing much wiping out. Note, however, the granular texture of the washes, which is often characteristic of this particular paper with its gesso coating.*

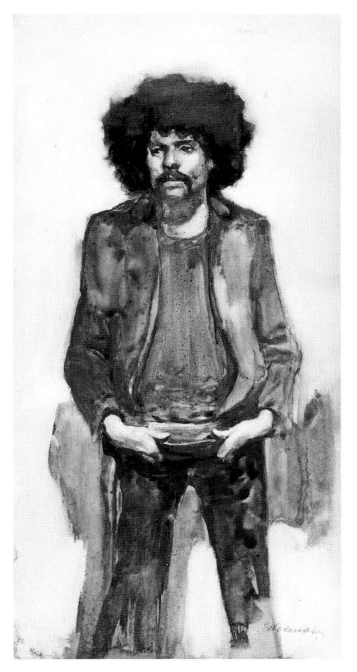

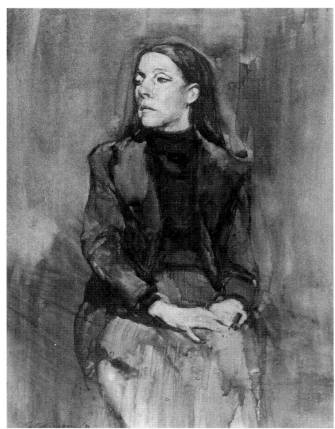

Irvine, 1971, watercolor on gesso-coated watercolor board, 14" x 10' (36 x 25 cm), collection of the artist. Among all the paintings I've executed on gesso panels, I've retained a special affection for this one because, for one thing, it was one of those rare occasions when the paint and the surface really worked well together, and I could relax a bit. My only reservation lies in the fact that the left arm was rather hastily drawn. I never noticed the error until the painting was long finished and framed.

Afro, 1970, watercolor on gesso-coated watercolor board, 15" x 8½" (38 x 22 cm), collection of the artist. Here's a small painting that came off rather well on the gesso surface, although there are passages in the clothing that I would probably do differently now. I left a lot of things "as is" because I was hesitant about working—or rather reworking—any area too heavily. Later washes had a tendency to pick up the underlying color. Besides, each piece of paper, with its gesso coating, was unpredictable. Every time I started on a new sheet, I had to gauge the surface and determine how congenial it was going to be. This was one of the things that finally led me to abandon gesso-coated stock.

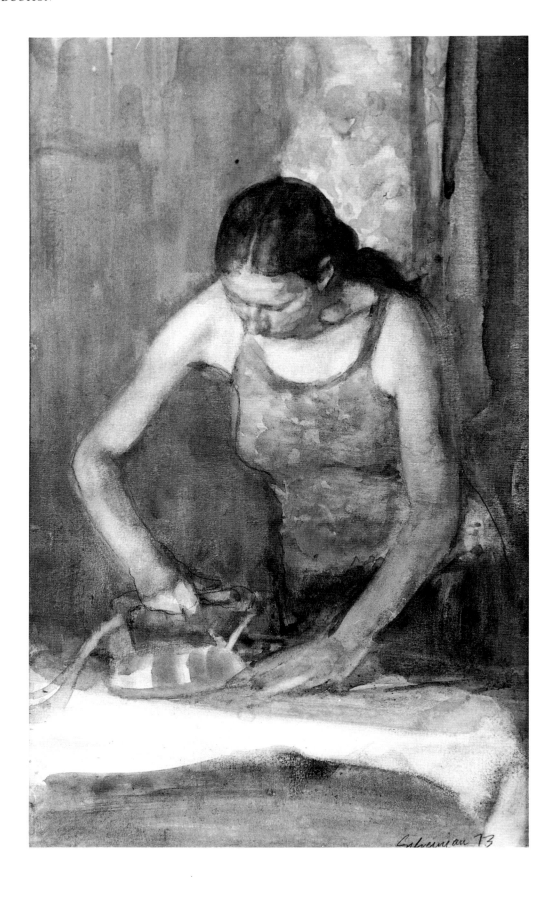

But finally, my patience gave out. The paper was just too unreliable, making me pay more attention to the technical means than to the painting as a whole. I also found it frustrating to spend so much time preparing the panels.

Then, when I was in Italy in the summer of 1974, I came across an interesting paper that was something like cardboard with a clay-coated surface. At first, this new paper seemed to offer some solutions to the problems I was trying to solve with those gesso-coated panels. But this new paper had its own problems. The paint dried in a flat, curiously non-transparent manner, something like gouache. The painting surface *was* consistent. The color dried the same way each time, but seemed to turn dull. The vibrant colors on my palette lost their vibrancy on the paper. And very often, the second and third washes would mingle with the first and prevent me from building up successive washes of color to develop the forms. I was also worried about the durability of this paper. Although I felt that the inert clay would hold up well over the years, I had no idea of the chemical content of the paper itself. I'm happy to report that these paintings are *still* in excellent condition—a heartening sign—but the evidence is still far from conclusive.

This exasperating paper chase finally came to an end when I decided to try three-ply plate bristol paper, which is easy to find in most art supply stores and requires no special preparation. (At first, I tried dry mounting this paper, but I soon found that mounting was unnecessary and a few strips of tape would do the job.) Actually, I had known about the bristol paper because my friend, David Levine, as well as a number of other artists, had been using it successfully for years. But I must confess that I avoided this paper for what may seem like a foolish reason. Ever since my association with the group of artists at the Davis Gallery, we'd been saddled with the criticism that all our work looked alike. It was essentially a superficial critique—a response to techniques alone—but it made me terribly wary of using any method that might feed that same kind of critical response.

*(left) **A Young Woman Ironing**, 1973, watercolor on gesso-coated paper, 14″ x 9″ (36 x 23 cm), private collection. This is one of the last paintings I made on that gesso-coated stock. The watercolor was one of the many studies I made for a series of laundresses—intended for a larger oil painting, which never came into being. Although I was able to do some fairly successful paintings on this erratic surface, I found it impossible to do the kind of subtle rendering that became possible when I switched to the smooth bristol paper later on.*

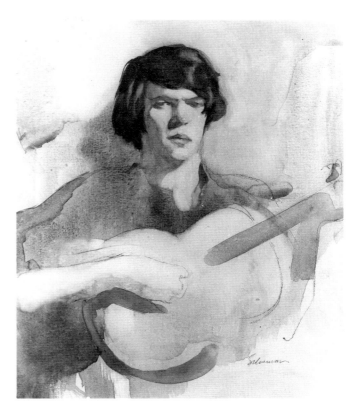

***Billy,** 1972, watercolor on gesso-coated watercolor board, 13¾″ x 11½″ (35 x 29 cm), collection of Arthur Adlerstein. For all of its unfinished segments, the portrait reminds me immediately of the young man and the period of his life when he posed for me. I think it's a strong image, perhaps because only the head is fully modeled and the rest of the picture is a kind of simplified "poster." And once again, I was able to overcome the tricky surface. Notice, however, the grainy quality of the wash to the left of his head. For me, it's something like a heavily grained canvas, whose texture obtrudes on the brushwork, subtly negating the surface texture of the pigment. I decided not to mess with this area since it didn't get in my way as I rendered the head.*

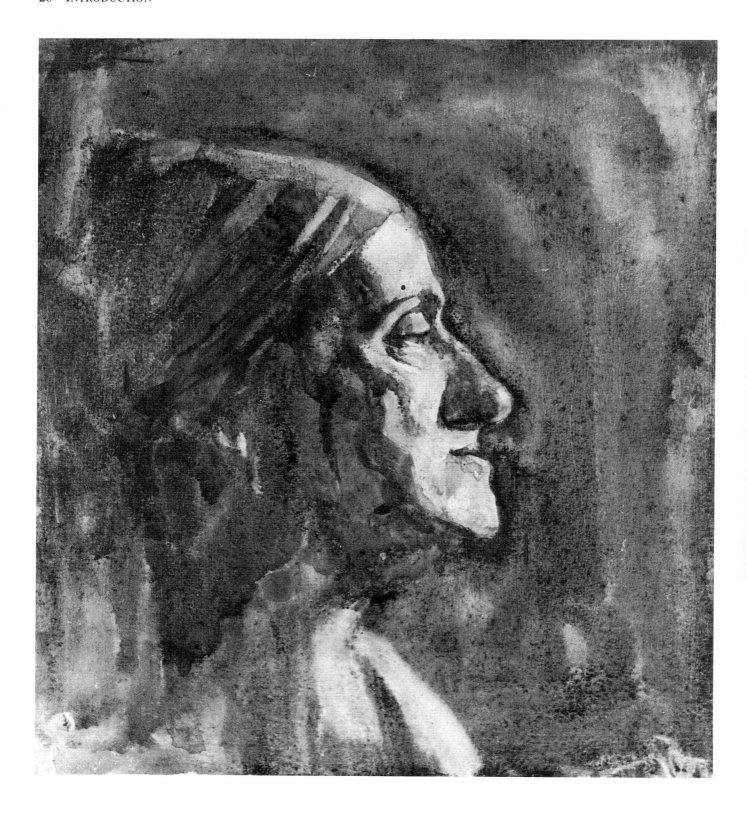

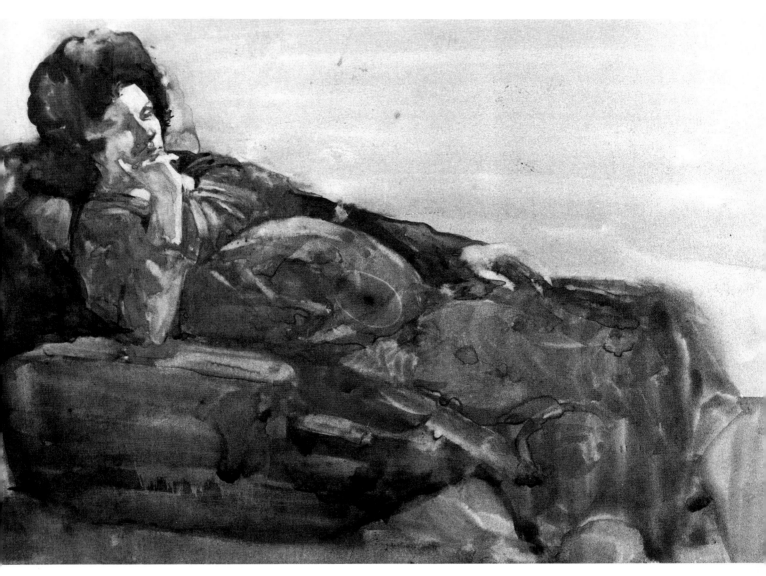

(above) ***Claire,*** *1971, watercolor on clay-coated paper, 10″ x 14″ (25 x 36 cm), collection of the artist. My wife Claire posed for my class once when our model failed to show up. Claire was carrying our first child at that time, and therefore she took the most comfortable pose to sustain her through the three hours. During that period, I was working on a clay-coated paper which I used for this painting. The clay surface made it difficult for me to render the broad, flat darks that I wanted for this image, and the watercolor became too active and spotty. I found it difficult to create simple, dark patterns, and to state the differences between the textures. I think I just gave up and stopped painting the picture. Clearly, there are many undeveloped passages. And the drawing is uneven. But seeing it again after so many years, I find that it looks a lot better than I remembered.*

(left) ***Head of a Woman in Profile,*** *1971, watercolor on gesso-coated watercolor board, 11″ x 10″ (28 x 25 cm), collection of Mrs. Margaret B. Wallace. I found this model particularly interesting in profile because of the contrast between her aggressive, jutting jaw and the passive, almost somnambulent eyes. I placed the head against a dark background to help dramatize this quality. The strong lights were picked out of this dark overall wash. I added warmer darks to the form of the head itself. I remember adding viridian to the background wash to stain the gesso, so later washes were less likely to pick up the undertone. The image is strong enough to make me forget the technical problems of that gesso surface.*

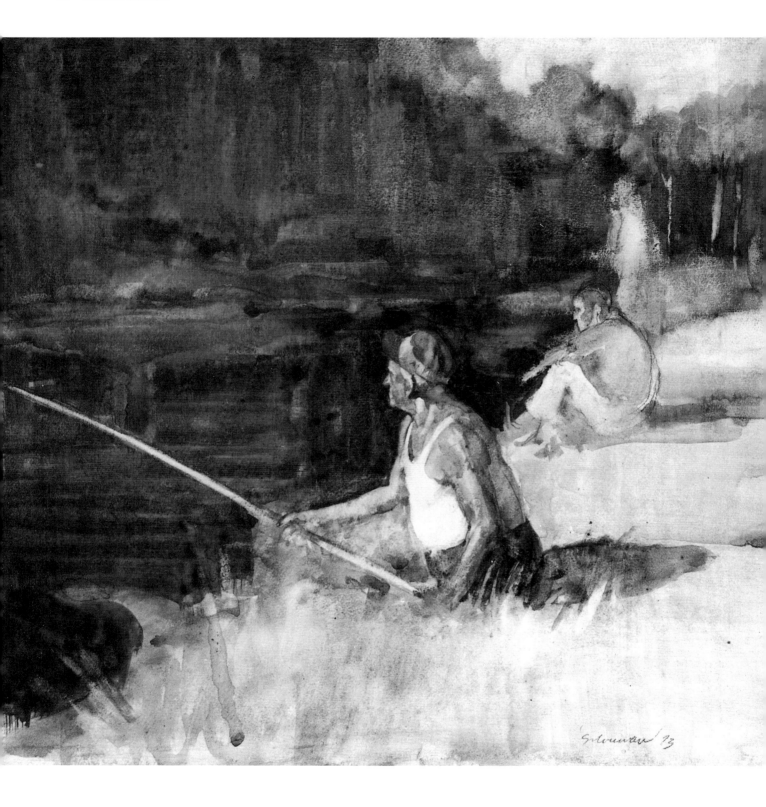

Eventually, I decided that yielding to this anxiety was just plain dumb, and a violation of all I believed about the validity of artistic borrowings. So I began to use these smooth (hot pressed) papers for my watercolors. These sturdy, common papers, so popular with illustrators, but neglected by most watercolorists, have given me the flexibility I need. The surface is tough enough to take layer after layer of color, as well as the repeated wiping and correcting that's typical of the built-up watercolor technique of nineteenth-century artists. I now find that I have the flexibility and control, as well as the confidence, to paint people in watercolor with some reasonable chance of success.

Looking back at this long search for the right paper—and the right technique of painting in watercolor—I must admit that I'm troubled by this preoccupation with technique. After all, the real issue in painting is not only *how* you handle the medium, but *what* kind of pictures you paint. The method must be wedded to the conception. But I also know that the search for the right technique is part of the bigger search for a personal language. And this is all part of the process of growing as an artist.

It's also taken me a long time to understand that there's no perfect solution. That is, there's no *permanent* solution. The means of painting—the brushstrokes and the lovely passages—will change again as the artist experiences new expressive needs. There will *always* be new problems. And there will be new solutions somewhere out there on the horizon.

(left) **Fishing,** *1973, watercolor on gesso-coated watercolor board, 14″ x 17″ (36 x 43 cm), collection of the artist. Someday I'll redo this picture the way I really want it to be. The place was a small stream that flowed into the Mediterranean. I was hoping that my painting would capture the sense of mystery and suspended time that I found in the subject. There are good things about the painting, but I don't think my conception has nearly been realized. Basically, I think the conception is still right. The sunlit figures are silhouetted against the ominous, dark of the trees, suggesting a tension between the seen and the unseen. But I was defeated by the gesso surface once again, and the rest of the painting doesn't quite come off.*

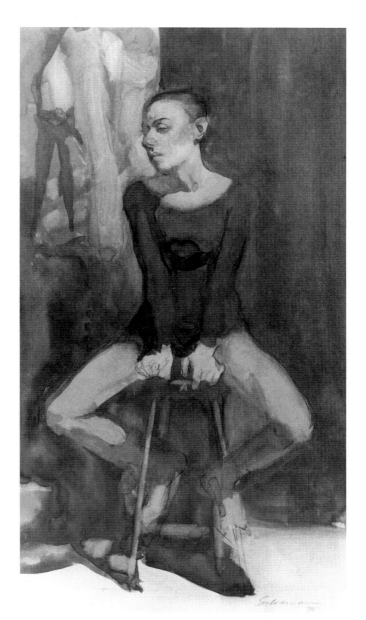

A Dancer, *1975, watercolor on plate bristol, 8″ x 18″ (20 x 46 cm), collection of Ira Steinberg. At this stage, I was working on plate bristol with a fair number of ups-and-downs. But I liked the surface and I also liked the way my color looked on it. In this painting, the strokes and washes have a very fluid look that gives the painting a feeling of energy and tension. The picture was done very rapidly and directly, without much wiping out.*

Painting Materials and Equipment

My studio habits—like my painting habits in general—tend toward controlled chaos. I'm just as capricious in the way I think about the materials I use. I often run out of certain colors and make do for several days—even weeks—with substitute colors. I think about getting a bigger palette, and then I put it off. I'm the same way about brushes. I have impulsive bursts of painting activity, balanced by periods of rumination, with interruptions for other projects like doing illustration. But underneath this unplanned, sometimes frantic way of operating, there lurks some sort of method. I have a lot of habits that I learned a long time ago when I was a student. Despite some small drawbacks, these habits are still quite serviceable.

My paints are usually a mix of domestic and imported watercolor brands. The British Winsor & Newton colors have been the mainstay of my paint supply, along with the American Grumbacher colors. Several years ago, I favored pans of watercolor. Although pans are more vivid in color because the pigment is more concentrated, I abandoned them for tubes because I wanted a bigger palette, and I also found that the pans seemed to need replacement too often. Now I buy large tubes and keep them wrapped in plastic bags, with a wet sponge enclosed, to keep them from drying out.

Earth Colors: Let's start with the earth colors, which seem to be a kind of security blanket for me. I'd feel uncomfortable without them.

My earth colors include yellow ochre, golden ochre, raw sienna, burnt sienna, raw umber, burnt umber, and sepia. I use the ochres very often as a preliminary ground color for a picture, as you'll see in the demonstrations. And I often add a bit of opaque white—Winsor & Newton Designers Gouache—to this ground color. I frequently use the golden ochre and burnt sienna to model a form—such as the dark side of a head—or for accents like the underside of a nose, the eyesockets, or creases in clothing.

Raw umber and a touch of opaque white make a wonderful, warm gray that I can use as a secondary wash or a local color in a picture whose palette is composed mainly of earth colors. I rarely use the burnt umber and sepia as local colors, but I do use them for accents or to mix with the ochres to give them a slightly more gritty cast.

Yellows: In the past, I've used chrome yellow and lemon yellow, but now I favor gamboge (either gamboge genuine or new gamboge) because it's more versatile in mixing. The gamboge makes lovely, earthy greens in combination with Prussian blue, and also gives me luminous, warm washes.

I've recently found that Naples yellow is a valuable addition to my palette, particularly for mixing, since this slightly opaque color actually contains some opaque white in the pigment. (The color varies with the manufacturer, tending more toward orange in the Grumbacher brand and more toward lemon yellow in the Winsor & Newton brand.) I often add Naples yellow to vermilion or cadmium red to make a flesh color. And I occasionally mix Naples yellow with ultramarine blue to make a kind of off-cast, gray-green wash.

Blues: The three blues I use most often are Prussian blue, which is harsh and strident as the name almost suggests; cobalt blue, which is more subdued than the Prussian; and ultramarine blue, which is "cool" and delicate. (I use Antwerp blue *occasionally*.) I like to use Prussian blue as an accent color in a painting that's mainly in warm earth colors; Prussian blue mixtures have a green tendency that seems to work well in this setting. Because the Prussian blue is so dense and powerful, I generally use it in very diluted form.

Ultramarine blue behaves in a special way in washes, puddling and drying to form interesting textures; it's also airier and more tractable in combination with a color like alizarin crimson, making very useful purple mixtures. Recently, many of my pictures have had a cool palette, in which ultramarine blue plays an important part because it behaves so well (and stays in its place) in so many mixtures. I like to use ultramarine in large washes because the color flows on well and can be removed so easily when it's mixed with a bit of opaque white. Ultramarine blue is also helpful in landscapes because it's so cool and atmospheric.

Greens: I use green frequently in my work, but I'm always a bit wary of the tendency of viridian and Hooker's green to stain the paper. I wind up mixing these greens with earth colors. However, used with some care, these colors are lovely for accents and patterns. Occasionally, I add them to ochres to cool the dark side of a face.

Reds and Oranges: My primary reds are vermilion and cadmium red, occasionally supplemented by Winsor red. I'm especially partial to vermilion, used in its pure state for a very rich, yet translucent color note. I mix cadmium red with a touch of opaque

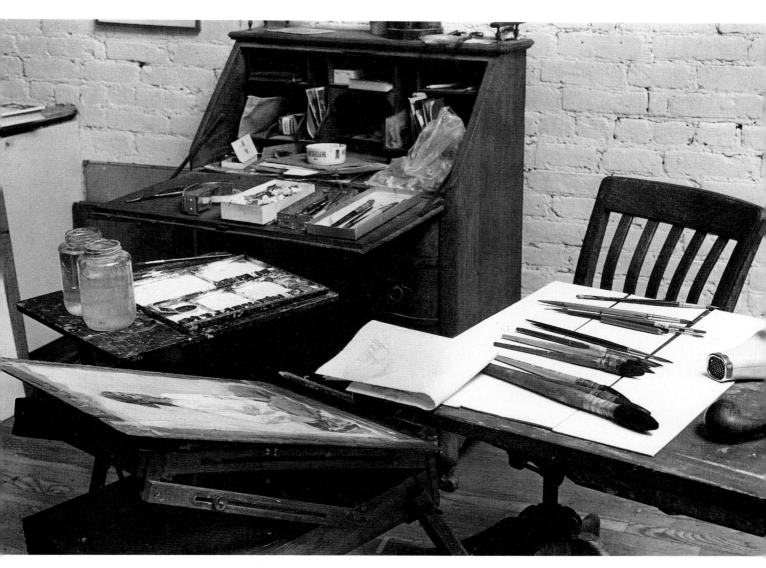

white where I want the flesh to tend toward pink in a cool painting. Cadmium orange is also important to me because it produces warm, luminous washes.

Gray and Black: My last important colors are Payne's gray and ivory black. Used thinly or mixed with opaque white, Payne's gray appears frequently in my pictures; these delicate mixtures work beautifully when I want to add cool gray darks to shadow areas. Ivory black produces stronger grays, which I normally modify with other colors.

Palette: My studio palette is simply a large watercolor box. For years, I've been thinking about getting a simple butcher's tray for mixing. These work well in the studio, where much of my work is done, and they require less frequent washing. But I just haven't gotten around to buying one.

My Watercolor Corner. Here you can see my palette, water jars, brushes, and the portable easel on which I rest my paintings. I keep the palette and water jars at my right hand for immediate access. Sometimes I use an old hairdryer to speed evaporation in exceptionally soggy or runny areas of the picture. The palette, easel, and table are all at about the same height so I can work sitting down.

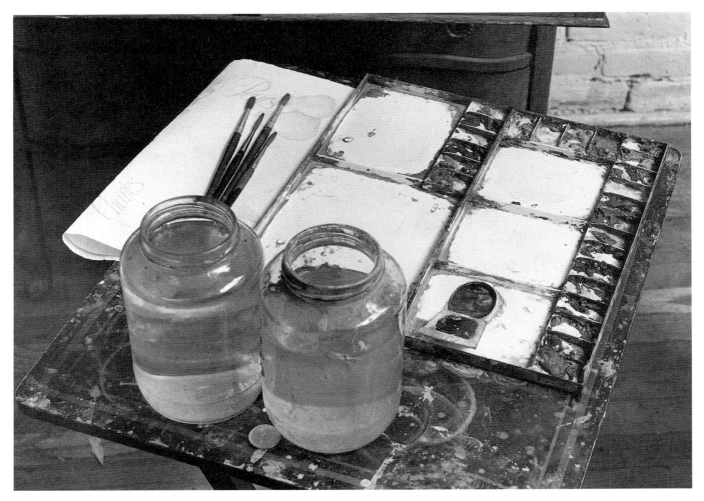

My Palette. *I use a medium-sized, folding box that accommodates twenty-four colors squeezed from tubes. In practice, the palette often contains no more than a dozen freshly squeezed pigments, since I really have no patience to set up properly. I keep two water jars available so that I have a reasonably clean supply of water. Both of them tend to get rather murky. My brushes are resting on a folded paper towel.*

Easel: Because I work in various positions, both standing and sitting, I find that portable easels are most adaptable. Setting the legs at half length and tilting the easel to about a forty-five degree angle, I can stand or sit with relative ease. If I'm working on a particularly small area, I usually have to straddle the box portion of the easel in order to rest my arm. To paint broader areas, I find it easy enough to stand and still be within arm's length.

A small, folding table holds my paint and water. A nearby drafting table with wheels is for excess brushes and possibly some visual aids. I work about fifteen feet from the studio sink, where I change water as I paint. I suppose I could work closer to the sink, but I welcome the occasion to get up and pace around.

Paper: My paper is Strathmore plate bristol, either three or five ply. I prefer the Strathmore bristol paper because the surface finish seems to be tougher. Other brands tend to absorb the paint more and are therefore less "wipeable." I also paint on some leftover

Whatman cold pressed paper (called *not* pressed in Britain), which is no longer made, and on Fabriano hot-pressed paper. Because it's imported from Italy, the Fabriano may be hard to find. It's a very smooth surfaced paper and allows me to do some *selective* and delicate rubbing and wiping, although this must be done with great care, since the surface isn't nearly as tough as the bristol.

To keep the paper from buckling when wet, most watercolorists fix their paper to a rigid surface of some kind. The usual solution is stretching—wetting the paper and then taping it or tacking it down so it stretches tight when it dries—but I find that too much trouble. I've tried dry mounting sheets of watercolor paper, like photographs, but this also turned out to be a lot of extra work, and much too expensive. Now I just use simple packing tape to fix the edges of the paper to a plywood or hardboard panel. I don't bother to dampen the paper, but just tape the sheets down while they're dry.

The bristol papers, especially the thick, five ply, tend to curl very forcefully, and can even peel right off the board, even though they're taped. You've got to use wide tape to hold the paper down: three-quarter inch or even an inch wide. I've tried the half-inch width and it doesn't provide enough grab. The bigger the sheet, the more it's likely to curl. So use the widest tape you can get.

One advantage of the heavier bristol paper is that you can use both sides. If you're not satisfied with a picture painted on one side, you can flip over the sheet and use the other. It's best to wash off the unsuccessful painting and then retape it, face down. In that event, the paper tends to curl far less; in fact, it seems to wind up totally flat. It's eventually dawned on me that I can reduce the curl problem by soaking the reverse side of a fresh sheet, placing it face down on the drawing board, and then taping the dry side.

If you're going to try the smooth bristol paper, you'll have to be patient and get used to the fact that the paper receives the watercolor in ways that are different from conventional painting surfaces. For example, you don't feel any drag in the brush, which seems to slide over the paper. Until you learn to make the necessary adjustment in your brushwork, the stroke seems almost slippery and unpleasant.

The paint not only dries to a different shade, but it dries darker, not lighter, which is just the opposite from what you've learned about painting watercolors on conventional paper. You'll also find that the second and third layers of paint will get streaky if you don't float them on very gently. However, after you rub the surface to remove paint or model a form, the paper tends to change its behavior and take the color

more smoothly. With this in mind, I often wipe a portion of a picture just to change the look of the paint.

You've got to work with this paper for quite a while to understand its characteristics and accommodate your technique to it. For example, you'll find that the grays—when they contain opaque color—have to be puddled on in a much lighter value so they won't dry too dark. You'll also find that textures and brushwork may appear different when the painting is in its final, dry state. Frankly, this kind of controlled accident often keeps me in a state of prolonged anxiety about the outcome of a picture. But this isn't necessarily an obstacle. Such quirks in the behavior of the paint often suggest unexpected courses of action as the picture develops. All this adds to the excitement and spontaneity of the process.

Brushes: In the process of painting a watercolor, my brushes play an even more subtle role than the brushes I use for oil painting. In my earliest watercolors, I generally used the famous Series 7 Winsor & Newton sables, which were—and still are—excellent brushes. But I eventually found that I wanted brushes that were softer and held more water. Like my search for the right paper, the search for the right brush has turned out to be a problem.

Back in the 1960s, I came across some watercolor nibs like those used in the nineteenth-century. They were just a cylindrical ferrule with the hairs stuck into one end, the whole rig designed so that you could fit it over a wooden handle and then throw away the nib when it wore out. Such nibs were once sold on both sides of the Atlantic, but, like California condors, have almost become extinct. However, I've recently discovered these nibs at Pearl Paint, a large art supply store in New York City, and perhaps these imports may soon be available in other major stores. They're excellent for their ability to soak up and release paint, for floating washes, and for painting small details.

However, these nibs were small brushes, and I needed something bigger to lay in broader areas of color. Once again, I found that the big brushes in my local art supply store were too stiff. But somewhere I found an old fashioned French brush made of squirrel hair. This brush suddenly opened up the possibility of really flowing—I mean *leaky* flowing—washes. Yet it came to a needle sharp point. When the French brush began to wear out, I found that the dealer had stocked only a few and never reordered, so I began looking for a substitute.

I found a mop-like Grumbacher brush that was virtually identical. When I went back for more, I found that this was extinct too. I still use this old

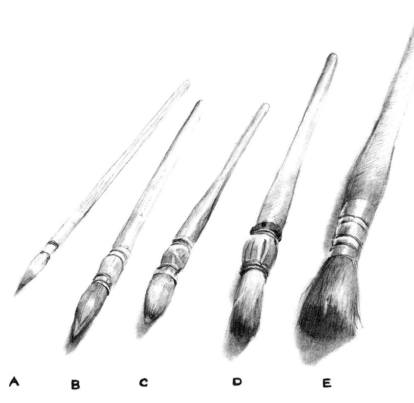

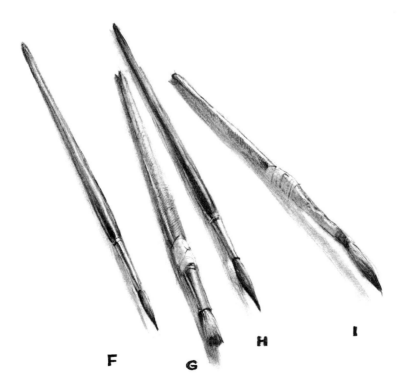

Brushes. *At the extreme left,* A *is a small French wash brush with sable bristles, excellent for small scale pictures that require both watery paint and precise rendering.* B *is a rabbit-hair version of the same brush, but much larger. Bought over nine years ago and still serviceable,* C *is my first French brush. The domestic equivalent of the French brush is* D, *once made by Grumbacher, but no longer available, as far as I know. Also made by Grumbacher,* E *is a large mop that's useful for large-scale pictures and for laying in broad washes.*

The brushes labeled F *and* H *are Artsign brushes—often designated as liners in the art supply stores—apparently an extinct species now, unless they can be found under another brand or with a different title. They're marvelous for small details. A survivor of many wars in the studio is* G, *an old sable watercolor brush that I use for lifting out small details. Its worn-out stiffness has become its chief asset. Another venerable brush is* I, *an English nib that's wonderfully versatile, like the French brushes. The ferrule looks rubbery because it's been dented by years of abuse—which haven't affected the functioning of the bristles.*

mop-brush for very large surfaces where the shape of the stroke isn't important.

Now, at last, more of the French brushes have come into this country. They're labeled Isabey and Sauer and are available in squirrel hair and sable. By the time you read this book, I hope that these brushes will be available in the larger and better art supply stores.

Another extinct species was an Artsign brush—with long hairs, intended for lettering, I think—that I found excellent in the smaller sizes. I bought out the stock in my local art supply store. I think I must have the last remaining two dozen of these brushes in the city, and maybe in the world!

To summarize, I need brushes with three significant qualities. They must be able to hold a lot of watery color. They need to be very flexible—more flexible than the fine, expensive sables that most watercolorists use. And they should be able to come to a good, sharp point.

Of course, no two artists have exactly the same needs. I've had to do a lot of hunting to find the tools that match my personality, style, and methods. And you'll probably have to do the same thing if you're not satisfied with the brushes commonly sold in most art supply stores.

I should mention that I *have* found a use for some of my older, shorter-haired, stiffer brushes. I use them for picking out the whites and the light areas in very detailed passages. For example, in some of my portraits of women, I use these brushes to wipe away strands of hair or for creating pale stripes on the patterns of clothing. Even though these brushes are quite worn by now, they still serve me well.

Paper Towels: The most important wiping tool is just a common kitchen paper towel. It has to be fairly soft and relatively durable. All I do is wrap the towel around my finger, dampen the absorbent paper with water, and then wipe. However, it does take a bit of experience to recognize just how wet the towel should be, and how much pressure you need to remove the pigment without abrading the paper. Naturally, it also takes experience to know how wet the brush has to be to do a similar job. The degree of wetness—that is, the amount of water in the brush—will determine how much paint is removed and how much control you've got over the wiping.

Painting Methods

Over the years, as I gradually found my way with watercolor, I was really involved in more than a search for a specific paper or the right brush. I was really trying to find a method of using watercolor that would be consistent with the way I painted in oil or pastel. I wanted to exploit the rich capabilities of the medium as practiced by the great artists whose work I saw in museum collections here and abroad. And I wanted to retain the unique qualities of watercolor.

The work of J.M.W. Turner and Thomas Eakins were particularly important to me because they helped me see that there needn't be a significant difference between watercolor and oil. Looking at Eakins's work in particular, I saw that his oils and watercolors were amazingly close. In Eakins, I saw that figure painting could be brought to the same level of complexity and finish in watercolor as in any other medium!

I began to search then for a similar harmony between my watercolors and my work in other painting media. I wanted to reach the point where I could structure a watercolor with the same ease and lack of concern that I had when I worked in oil. I wanted to feel free to change portions of the picture easily, without ruining the painting surface. I wanted to be able to model the forms gradually, by degree, without worrying unduly about preserving the whites—the usual headache of portrait and figure painting in watercolor. In effect, I wanted to develop the transparent watercolor equivalent of modeling with opaque paint, working broadly and freely as I did in oil. Conventional watercolors rely on modeling the form by going from light to dark, adding successive layers of color until the image is complete. I wanted to be able to model from dark to light just as easily, although this is a technique that we normally associate with opaque painting media. Yet I also wanted to preserve the watery, translucent look of watercolor.

With all these requirements in mind, I still wanted to stay within the feeling of classic watercolor. This meant that I couldn't rely on opaque color to model forms or retrieve the lights. I also knew that conventional watercolor techniques allowed a certain amount of scrubbing and scraping, particularly on rough, heavy papers, but *not* very often. So I rejected both of these solutions—opaque painting and rough, heavy paper—and began my long series of experiments with different papers in order to find my own resolution of the problem.

I found the resolution not only in the hard, smooth surface of the plate bristol, but also in a way of handling paint. Although I started out with the idea that my method of using watercolor had to be parallel, in some way, with my method of using oil, the way I handled the paint had to be different. It was a matter of physical touch. I had to learn how to guide puddles of paint that would flow or leak out of the brush,

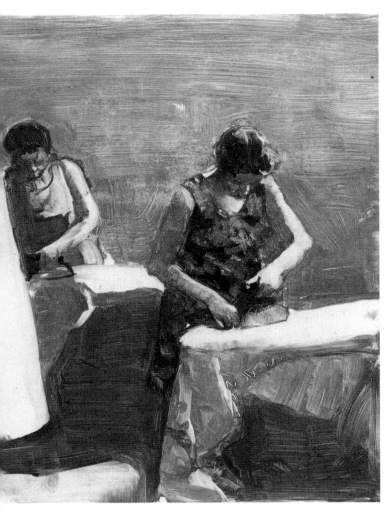

Hand Laundry, *1974, monotype, 15" x 13" (38 x 33 cm), collection of the artist. This isn't a watercolor, of course, but a monotype. However, I think it demonstrates the harmony between my work in watercolor and other media. This is a kind of print that's made by painting in oil on a Plexiglas plate and then printed by running the plate through an etching press. The oil paint slides around on the plate in a manner not unlike the way watercolor behaves on the smooth bristol surface. Lights are often wiped out, as in the left arm of the foreground figure and the tops of the ironing boards. In general, shapes are modeled very sparsely. As in watercolor, the modeling can be left very broad and suggestive—or carried to a very high degree of finish.*

rather than pushing the brush against the surface and dragging the color around as I did with oil. This meant finding unorthodox brushes that could hold a lot of fluid pigment, and yet retain a reasonably good point. And I had to find a way of removing color from the painting surface as easily as I applied it.

I saw that my painting method was going to become a kind of alternating process: applying broad washes of color; wiping out patches or parts of these areas to create light and dark patterns; adding more color to establish more density or richness of color; and then modifying all this by doing more wiping, rubbing, and painting until the image was realized. This is the process that you're going to see in the demonstrations that follow the text you're now reading.

But there were other painting problems that related to my oils and pastels. I found that some of the colors I wanted—muted grays, blue-greens, and pinks—were just not subtle enough when I merely added water to the pigment. This was especially true in my portraits, where I preferred to "gray out" the darks when I modeled the features. I knew how to do this in my oil and pastel paintings, and I wanted to find a way to achieve the same thing in watercolor. By adding a small amount of opaque white designers gouache to my transparent watercolors, I found that I could produce some of these very subtle tones. The color wasn't really opaque, but just a kind of colorful haze. Thus, some portions of the picture could be given a subtle, atmospheric feeling. I could also use this method to flatten the image by reducing the contrast between the lights and the darks. In this way, I began to play with a kind of ambiguous relationship between the rendering and the image. It's like saying: "Here's the real person—but remember that it's really just paint!

I've also become increasingly interested in using decorative patterns and textures in my painting as a foil for the fully rendered forms, such as a hand or a head. This is a device employed by Gustave Klimt in many of his early works. I was fascinated by the way Klimt painted intensely colored, flat patterns on figures that were otherwise classically rendered in the round, still looking three-dimensional despite the richness of the flat pattern. By "graying out" the color of the figure, I can enhance the feeling of dissonance between the paint and the figure itself, and thus evoke a whole range of mysterious, unexpected qualities.

This combination of materials and methods—smooth paper, supple brushes, flowing color, hints of opaque white in my color mixtures, and the alternation of painting and wiping and repainting—has ex-

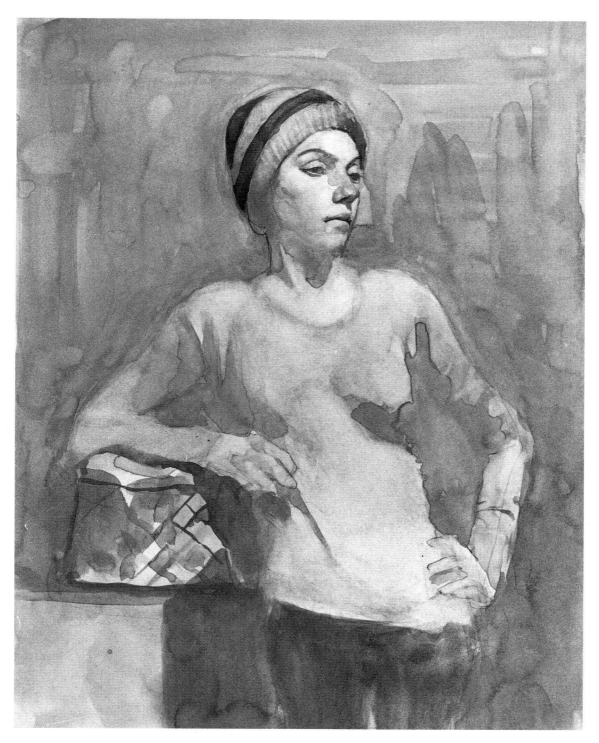

Young Woman in a Wool Cap, *1975, watercolor on plate bristol, 15″ x 11″ (38 x 28 cm), collection of Mrs. Beverly Golden. I don't know if it's evident to anyone but me, but I feel that this picture still shows a kind of failure of nerve, left over from my earlier difficulties with watercolor. I was still a bit afraid to spoil something. Hence, the unresolved strokes scattered throughout the surface, especially in the background. But there are enough successful aspects—the subtle shadings within the figure and the suggestion of the model's state of mind—that combine to overcome these drawbacks.*

panded my "vocabulary" to the point where there seems to be no limit to what I can do with watercolor. I have a sense of freedom that allows me to tackle a wide range of pictorial situations that might otherwise seem impossible with watercolor. In practical terms, I find that I can use watercolor to deal with many pictorial problems that I might actually find more difficult in oil, such as rendering decorative patterns. For me, watercolor is now as versatile and flexible as any other medium.

Painting a Picture

Painting in watercolor means being patient with the medium. First of all, you must recognize that it takes time to understand how to use watercolor, learning to plan your color mixtures so that you can anticipate the hues and values these mixtures will produce when they *dry*. Despite the conventional assumption that watercolors are a rapid medium—which it certainly *can* be—my particular methods tend to require more time.

Let's start with the paper itself. Getting used to the behavior of the plate bristol surface takes time and experience. You'll find that the plate bristol is hard and shiny, but you'll also discover that the three ply behaves somewhat differently from the five ply. The thinner sheet feels more slippery when I apply my first colors. When this happens, I know that I've got to wait for my second and third layers of paint—and also wait for the change that takes place in the surface as I wipe and rub—until the paint behaves exactly as I want it to. I have to be patient, knowing that the abraded fibers will become more absorbent and spread the paint in a more congenial way after I've been working on the paper for a while.

With time and experience, I've also found that the first layer of paint can be wiped away easily when it's wet *or* dry, while later washes can be taken out most easily *after* the paint is dry. In the later stages of the painting, I've found that I may damage the surface if I don't let the fibers dry thoroughly before I start to remove any color.

Ski Cap, 1978, watercolor on plate bristol, 14″ x 9″ (36 x 23 cm), collection of the artist. This is another example of the versatility and durability of plate bristol. The picture is actually painted over another unsuccessful painting that I wiped out! The black background helps to obliterate any trace of the earlier picture. The new painting was done from a sketch of the model in this pose, which I found more interesting than the original pose. The black background helps to set the mood for this rather intense, if not depressing, image. The modeling of the coat and hands is very simple—and there's only a bit more modeling in the face.

(left) **Jenay,** 1981, watercolor on cold-pressed paper, dry mounted on rag board, 12″ x 9″ (30 x 23 cm) collection of the artist. I recently painted this portrait on traditional watercolor paper, modeling the form from light to dark. However, I also used some opaque white on the dark side of the head—a carryover from my technique on bristol. The combination of transparent and semitransparent color worked because I puddled the semitransparent wash into a wet area and allowed the color to seep into the first transparent wash. The picture was very rapidly done, taking me no more than forty minutes.

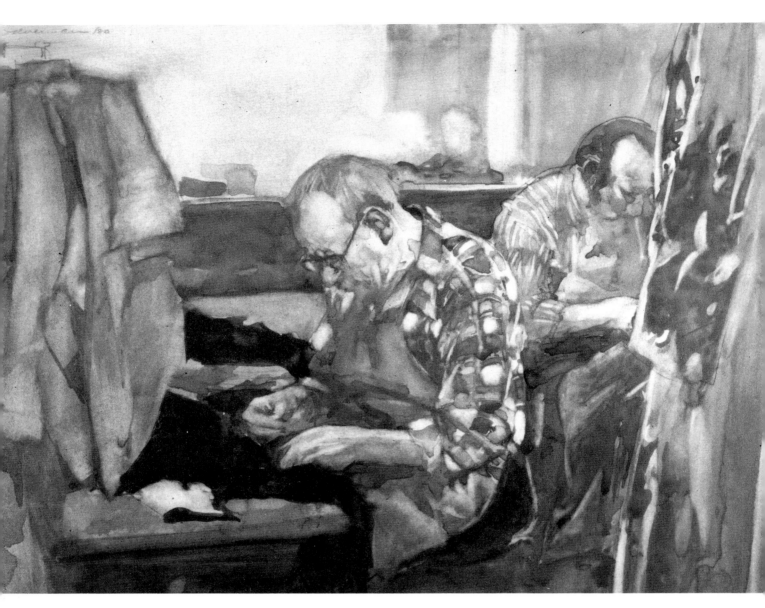

Two Tailors, *1980, watercolor on plate illustration board, 14″ x 20′ (36 x 51 cm), collection of Mr. and Mrs. Milton Bates. On occasion, I've used a plate finish illustration board, also made by Strathmore. The paint moves over the surface in a slightly different manner, but it's just as workable. One purpose of this painting was to explore the idea of combining flat, decorative patterns—such as the shirts of the workers—with fully modeled forms such as the heads and draperies. This combination works especially well in watercolor, particularly on the plate bristol surface. You can see the usual wiping and lifting within the heads and hands, as well as in the background. I've also lifted small, precise shapes from the patterns of the shirts.*

If I wipe out any areas at the very beginning of a painting, it's usually because I'm planning—just as I would with conventional watercolor papers—to hold onto very clean whites or very pale values. These areas won't be quite so white if I wait to lift them later on in the painting operation. In this situation, I generally use a paper towel, wrapping it around my finger, wetting it slightly, and then rapidly picking out the pale patches. As the picture develops, I use both the towel and a blunt, damp brush. The brush is for details or small spots that don't permit me to use the finger-towel combination precisely enough.

It's important to avoid too much wiping out. It takes patience to build up the picture. Many of my students fall into the trap of *depending* upon this wiping technique, resorting to wiping as a way of solving all problems—which it doesn't. The picture still has to be painted! The forms still have to be built up in layers of transparent color. And the surface of the paper has to be respected and not punished, even though it will take a great deal of abuse. One way to avoid too much wiping is to deal with the *whole picture* and not get stuck on any one detail. There's always a lot of direct painting to do before you consider wiping or rubbing out.

In the same way, you've got to be wary of depending on opaque white. Although I use opaque white gouache very selectively in mixtures—almost invisibly—I warn my students that opaque white won't solve all their pictorial problems. I don't think you can use it to patch up a watercolor that hasn't come off. Although I sometimes think that I use white a bit more often than I should, I always take care to apply it in a broad, washy way, usually mixed with transparent color, thus preserving the translucency of the medium and sustaining the fluid quality of watercolor. Even when I use a certain amount of opaque white throughout the painting to get that grayed-out mistiness, I never build up a solid layer of opaque color to cover up a mistake. I add touches of opaque white to transparent watercolor because that translucent effect is essential to the effectiveness of the image. I try to avoid using opaque color as an afterthought.

One last bit of information. In the course of using opaque white in my initial washes, I've discovered that white in the ground color prevents the surface from being stained by very strong dye colors, such as Prussian blue, alizarin crimson, or Winsor red. I've also found that these initial washes seem to wipe out more easily when they contain a bit of opaque white.

I've found that there's another bonus to this semi-opaque ground color. Successive layers of transparent color, applied to develop the forms or figures in the painting, seem to flow on with greater ease and delicacy. When these later washes dry, especially if they're put on in wet globs flowing off the brush, they dry with a ring around the area of the puddled paint. (You can see the same thing happen on your palette!) These "puddles," often occurring in unexpected configurations, have a provocative visual impact, and often work to reinforce the modeling of the form. I must emphasize, however, they are controlled accidents. If pursued for their own sake—because they're often quite appealing in an abstract way—they merely end in a pointless exercise in "technique."

It's appropriate to mention that I'm not the only one painting watercolors on bristol paper in this particular way. Artists such as David Levine and Daniel Schwartz use watercolor in a similar way. Schwartz's paintings have influenced a whole generation of illustrators, who have imitated his runs and drips of watery paint. However, there's no special "secret" about the means of making such a painting. These stylistic devices take on significance only when they're *integrated* into the artist's personal vision. In Levine's paintings, for example, they serve to emphasize certain caricaturelike distortions in his figure pieces.

Photographs

In recent years, I've done a great many paintings from photographs, as well as from sketches and other studies. I find that there's no problem in working from photographs, provided that *I've* taken the photo and that I'm painting a scene or a figure that I've drawn or painted at least once before *from nature.* Thus, I don't feel that I can rely on the photograph completely. If I've already drawn or painted the same subject from nature—that is, if I've already had some direct interaction with the subject—then the subject looks more "alive" when I work from the photo. I can then read the photograph with some feeling that it's close to the real life situation.

This is one of the reasons that I value the weekly classes I conduct in my studio. These classes give me the opportunity to work directly from the model, constantly refreshing my repertoire of visual memories, which I can bring to a painting even when I'm working from a photograph.

Photographs are enormously useful when it's difficult for me to return to a particular site. A photo is also helpful when I want to change a painting dramatically, but no longer have the model before me. And sometimes I combine a photograph with the live model, possibly painting the figure from life and then painting the background from the photograph.

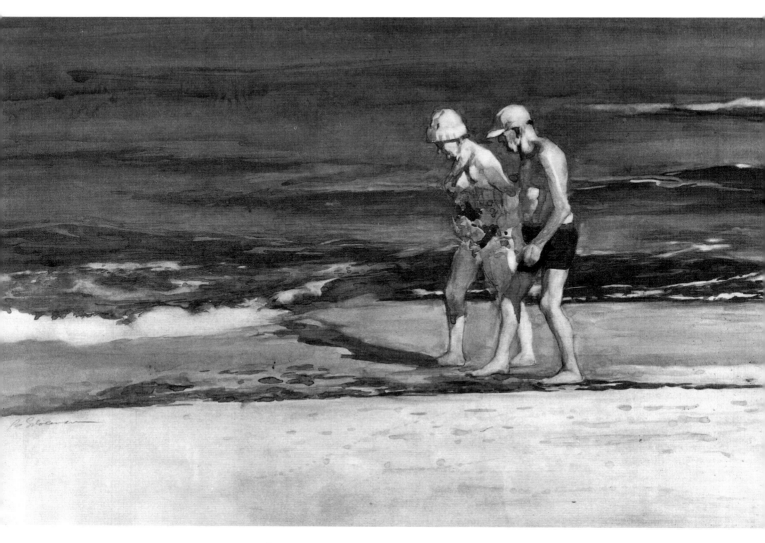

Pompano Beach, *1978, watercolor on plate bristol, 18" x 28" (46 x 71 cm), collection of Mr. Leonard Fertman. This is another example of my interest in the shoreline as a setting for an "event" that might easily be depicted in some different place. Watching the old couple in their bathing suits and hats, I found them both poignant and a bit comic. I tried to present them with some detachment by viewing the figures from a distance. Thus, it was important to devote a large amount of space to the background. The large background area served another purpose as well: to isolate the elderly couple in a way that suggested the isolation that older people often experience in the world onshore. I'll have more to say about this theme in my discussion of my first demonstration picture.*

But given the choice, I always prefer to paint from life. Even the best photograph freezes an experience and forces me to work harder to retrieve the life of the picture. In the long run, I'd urge you to avoid photographs, at least until your style and visual memory are developed to the point where the photo is just an anonymous aid to painting, and not something that dominates your work.

Painting Goals

Many of my pictures of people have the feeling of portraits, even if they're not portraits in the strict sense. Actually, I shy away from calling my pictures portraits because I don't like to feel locked in by the need to paint a likeness. Because I often get a good resemblance to the sitter, viewers are provoked to ask, "Who is that?" This actually disturbs me. What I'm really trying for is not a likeness, but a more "universal" representation of the figure—something that reveals the inner life of the person in the picture.

I suppose it seems pretentious to call these paintings "psychological portraits," but I do feel that I'm tuned into the interior state of mind of my subjects. The cast of a head, the sharpness of particular features, the way the mouth is pursed—these details all work to suggest a great deal that's otherwise unspoken. This interest in painting portraits is a response to that unspoken world that lurks beyond a more likeness. But don't misunderstand. I don't ignore resemblances. Far from it! The physical qualities of the subject, the cast of a head and the curve of a shoulder, are the visual cues by which those interior states are often revealed.

This quality in my work sometimes plays curious tricks. I remember one young women who posed for a portrait that just refused to reveal anything but a sense of deep-seated anguish. I worked on the picture many times, trying to moderate that quality, or at least trying to make it less obvious. But the portrait still conveys a kind of depression that defied all best efforts to eliminate the feeling.

After these many years of painting in watercolor, I've almost come full circle in my enthusiasm for the medium. Having struggled with watercolor for so long, I can once again experience something akin to my youthful exuberance. But now this delight is born of understanding, not innocence. I can look forward to the pleasures of the medium, though I still quake at the consequences: what will the *painting* be like?

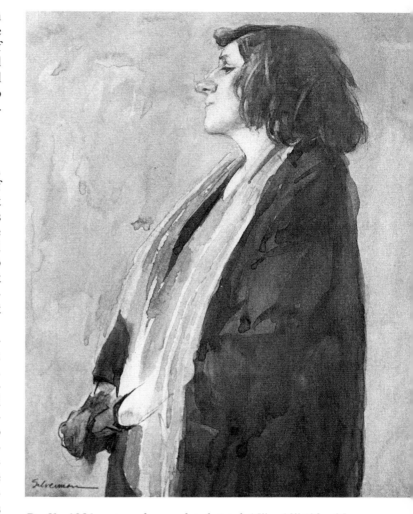

Profile, *1981, watercolor on plate bristol, 15″ x 10″ (38 x 25 cm), collection of Ms. Carolyn Talbot Hoagland. Although the painting was done on smooth, plate bristol, the texture of the pigment seems to suggest conventional, cold-pressed paper. This is because I wiped out an earlier, unsuccessful painting done on the same sheet, thereby feathering the surface slightly. However, the surface was still usable for this new painting. I decided to paint the picture quickly and directly—with less building up, wiping out, and repainting— partly because the surface was a bit abraded, but also as an exercise in a more traditional approach. I did wipe out some areas of the head and hair.*

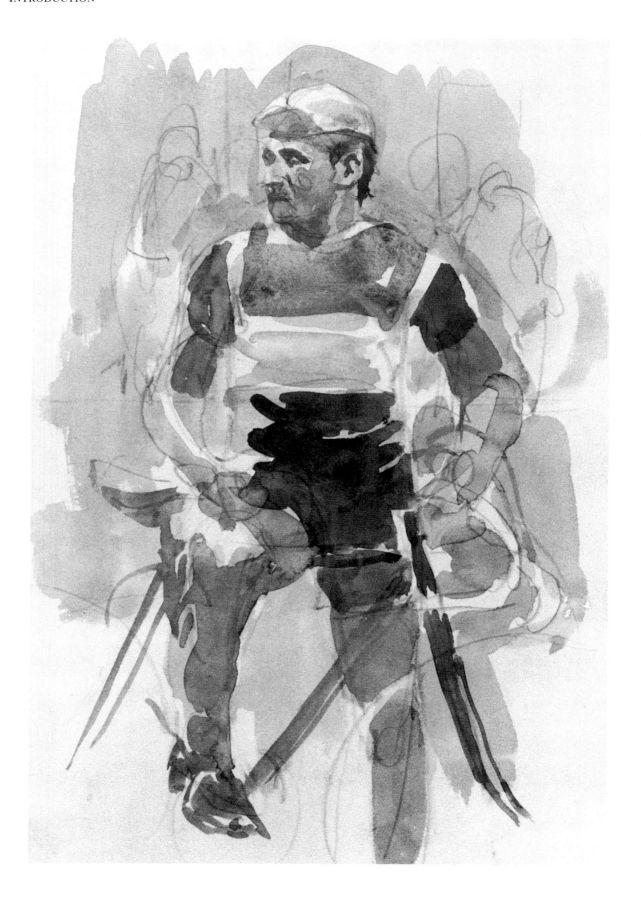

Afterword

It's been said that writing is a way of discovering what you really think. If this is true, then it's equally true that what you think also *changes*. Thus, two years or five years from now much of what I've written here might no longer be valid for me! I say this to remind you that all the devices, technical apparatus, and materials I've discussed in this book may become outmoded for me if my goals change. To be wedded to any method leads to a kind of mannerism—to a style for its own sake. And this inhibits the capacity to respond honestly and directly to the world around you. Learn what you can from this book. Be fearless. Have fun! Then be prepared to move on.

(left) ***The Rider,*** *1978, watercolor on hot-pressed watercolor paper, 10″ x 7″ (25 x 18 cm), collection of the artist. This is one of the small sketches I did in preparation for a large oil painting of an Italian bicycle rider. After many years of uneasiness about rendering a figure on conventional watercolor paper, I found that I was able to put down this study without a second thought. Most of the shapes are laid on as simple, flat washes. I'm no longer interested in this conventional technique for finished paintings, but I find it works well for quick studies like this one.*

Demonstrations

At this point, I'm going to let you watch half-a-dozen paintings evolve before the eye of the camera. These demonstration paintings weren't necessarily created for the book, although some were hastened into being by the publisher's deadline. All the demonstration paintings are part of my daily painting life—my ongoing themes and projects, both in watercolor and other media. Some of the paintings were done in the studio from the model. Others were painted in the studio from drawings and photographs of subjects outside the studio. And for a change of pace, there's one landscape that was painted on location.

The paintings in these demonstrations were made over a span of two years. Two of the paintings took as little as six hours to complete. Others took as long as six months. I must admit that some are not finished *yet*, though for the purposes of this book, they're complete enough to yield a learning experience for the reader—and for myself.

The painting entitled *The Tailors* took the longest time and presented the greatest difficulties. Prudence should have dictated selecting a different picture to photograph, simply because this one presented so many difficulties. Nevertheless, I persisted with this picture because I felt that there was something special in it—I'm still not quite sure what—and because I'm rather stubborn and hate to give in. Showing the story of this painting also satisfies my sense of truthfulness about how paintings are made, a process which isn't easy for me, despite the apparent speed with which I work.

Also in the interest of truthfulness, these demonstrations are written in a form that's something like a journal, recording the uneven, often contradictory development of each picture. At the beginning of each demonstration, I'll talk about the background of the subject of each painting, why I chose to do it as a watercolor, and some of the reasons behind the concept. As I talk about the stages in the painting process, I suspect that I'm going to behave as one of my students described me, watching me at work one day. He characterized my movements as much like a mouse, skittering all over the place, bumping into things, yet somehow getting back home in one piece. As you follow the story of these paintings, you should be prepared for a similar bumpy ride. I hope it will be an adventure of a kind, sometimes exciting, at other times disappointing perhaps, but rewarding in the end because it's the honest story of the way a painting happens.

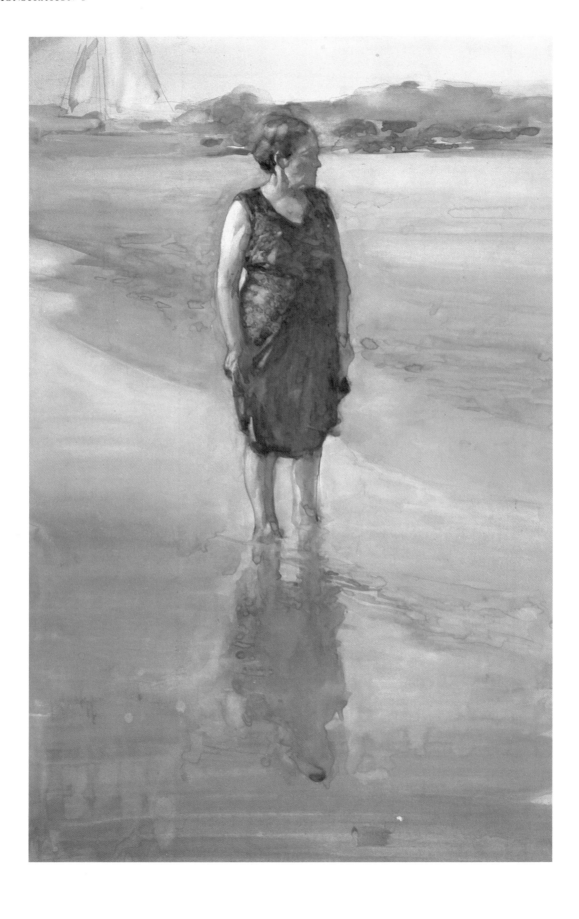

The Signora

Despite the obvious pleasures of the beach—and probably as a perverse reaction against all those glowing California and Mediterranean advertising images—my paintings of this subject have always been rather gloomy. (I suspect that I may be going to the wrong beach.) Perhaps it's no accident that I did my first such painting in Italy where bikinis go side-by-side with hundred-year-old print dresses worn by the elderly, and where the Italian film directors (like Antonioni) have shot scenes in which the beach seemed to be the setting for some mystical rite. I've also been struck by what the beach reveals about the anxiety about body and soul, which the Italians, among others, have never quite been able to resolve. All these issues have come to mind when I've found myself slung in a beach chair, squinting through the glare toward the cool unknown of the sea.

In these circumstances, I've rarely been able to muster the energy to paint directly outdoors. The problems of sun, sand, and the rapid shifting of bodies have been almost insurmountable obstacles. But I *have* been able to draw. And these drawings have given me the source material for paintings in the studio. Such drawings have been made to develop an idea, rather than as studies for an idea I already had

(left) **Evening at the Shore**, *1982, watercolor on plate bristol, 21″ x 14″ (53 x 36 cm), collection of the artist. I've often strolled the shoreline at the end of the day, experiencing the moment when the sun's harsh glare is muted and the sea makes one think of times past. And I've often gone with camera in hand, anticipating some image like the one that presents itself in this painting. The picture is not only a poignant moment in the life of the elderly lady, but also reflects much of my own state of mind. The bare composition emphasizes the solitary mood. For the same reason, I think I was right in eliminating virtually all detail outside the figure. As usual, however, I feel that the picture needs a bit more work—perhaps more detail in the background—after all.*

in my head. And to draw in this setting is most enjoyable. All those bodies, in every conceivable pose, and generally in a state of near nudity, are a welcome change from the limited, often repetitive and conventional studio poses.

Initially, most of my beach paintings were in oil. But I soon found that I was turning to watercolor, first for studies, and then, as my confidence grew, for paintings in their own right. With each new picture, I became more and more interested in the colorful beach chairs. Clustered in groups of twos and threes, they seemed to provide security in the hostile emptiness of the beach, serving as both refuge and prison. The chairs seemed to interact, almost physically, with the people who occupied them or sat near them.

The watercolor called *The Signora* grew out of all these ruminations.

I chose to paint *The Signora* as a watercolor because the late afternoon sunlight, the distant sea, and the sky had a kind of luminous unreality that demanded pale washes of color. I also thought that the print pattern on the older woman's dress could be rendered in watercolor in an easy and appealing way. As it has turned out in so much of my more recent work, watercolor enables me to render certain textural details that are essential to the painting. This texture—not just the quality of the brushstroke, but the alternation of detail and generalization—is one of the devices that I rely on to elicit ambiguity and contradiction.

The image was taken partly from a photograph and partly from drawings of figures sprawled out in beach chairs. The photograph showed an elderly woman seated on a table, next to the chairs, hunched over in semisleep, lost in an interior world of reflection or memory. The drawings showed a much younger woman wearing a bikini, reading, and caught up in another kind of imaginative world, far away from the here and now.

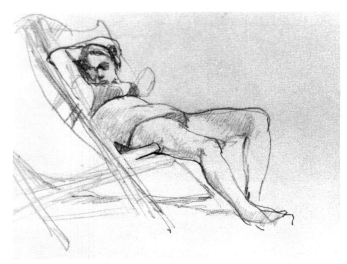

Reclining Figure, ca. 1977, pencil drawing, 6" x 8" (15 x 20 cm), collection of the artist. This is a sample of the many quick drawings I've made while sitting on the beach or roaming the shoreline. The "pose" lasted no more than three minutes. I barely had time to finish the drawing when the woman shifted her position in the beach chair. This is the kind of drawing that led up to the demonstration painting that you'll see in a moment.

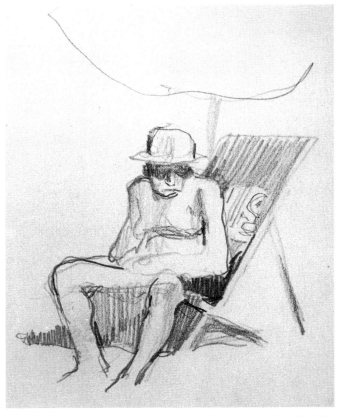

Figure in Beach Chair, ca. 1977, pencil drawing, 7" x 5" (18 x 13 cm), collection of the artist. This drawing was done furtively to make sure that the subject wouldn't notice me and change his position. I wasn't totally successful in concealing myself. He did become self-conscious and he got up in what seemed like a few seconds!

Beach Scene, 1978, pencil drawing, 6" x 9" (15 x 23 cm), collection of the artist. My original idea was to make a long, panoramic painting from this sketch, with the help of some others. But so far, I've used only the central fragment for the first demonstration painting in this book.

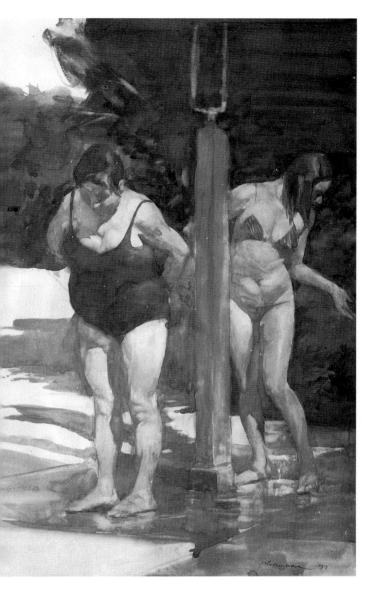

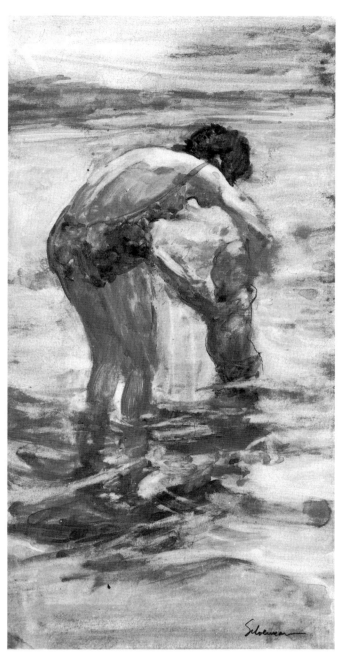

Black and Red, 1978, watercolor on plate bristol, 21″ x 15″ (53 x 38 cm), collection of Mr. and Mrs. Stanley Mandell. I'd done an earlier watercolor of a group of people washing themselves at an outdoor shower at the beach in Italy—and this picture was a fresh attempt at the same subject. The earlier picture was done on the clay-coated paper, which didn't allow me to develop the forms with the necessary complexity. This new picture was much more elaborately rendered. You'll notice that I left out the water and even the showerhead. This was something of an evasion; I wasn't really sure how to paint it. But I also felt that a literal rendering of the water would somehow be wrong. In the end, I think this was a wise decision.

Mother and Child, 1974, watercolor on clay-coated board, 8″ x 13″ (20 x 33 cm), private collection. I still have an affectionate feeling about this painting, although I'm disturbed by the relatively scrubby quality of the brushstrokes. There's a kind of ambiguous relationship between the mother and the child—is it reprimand or play?—that nestles comfortably in my own view of parenthood. This peculiar paint quality occurs in my other watercolors on the clay-surfaced paper—which I abandoned not long after I painted this picture.

Stage 1: I start out by taping my paper to the board and lightly sketching in the barest outline of the dominant shapes of the two women and the umbrella. My first wash is a flat tone of yellow ochre and opaque white gouache. I let this dry and then, instead of trying to render any form at all, I fill the outline with a more opaque, grayish wash, leaving only a sliver of light where I know that the crossed arms of the signora will be.

Stage 2: As I allow time for stage 1 to dry, I'm thinking ahead to the colors I'd like on the chair and the umbrella. I don't want these to compete with the central image, but they should be close to the strong colors of the beach equipment. I'll have to see what happens as the image evolves. Now I proceed to wipe out patches for the forms of the two figures. I use a wet sable brush—an old one that's worn at the point, but still sharp enough to use with precision. I redraw the figures with a charcoal pencil, knowing that these lines will be washed out as I add color. I paint grayish-orange values on the dark side of the signora's face to shape her features . And I add warm ochre and vermilion to her arms, plus dark patches for the hair. Black blobs literally drip off a long-haired brush in small circles to form the print pattern of the dress. Adding a bit of Hooker's green to this, I make the pattern for the towel that's slung over the back of the beach chair. I'm scurrying all over the painting, reaching for the highlights and deepest shadows. But the painting is still flat, still not modeled, so there are no smooth transitions, except perhaps in the folded arms and face of the signora.

Stage 3: I'm beginning to add patches of red to the younger woman's bikini and funky beach hat. I don't develop her features because her face will be minimally rendered in the shadow of the umbrella overhead. I'm aware that the feeling of the late afternoon slanting sun isn't developing as I hoped. Have to keep an eye on this. I'm adding warm values to the torso and legs, as well as the towel.

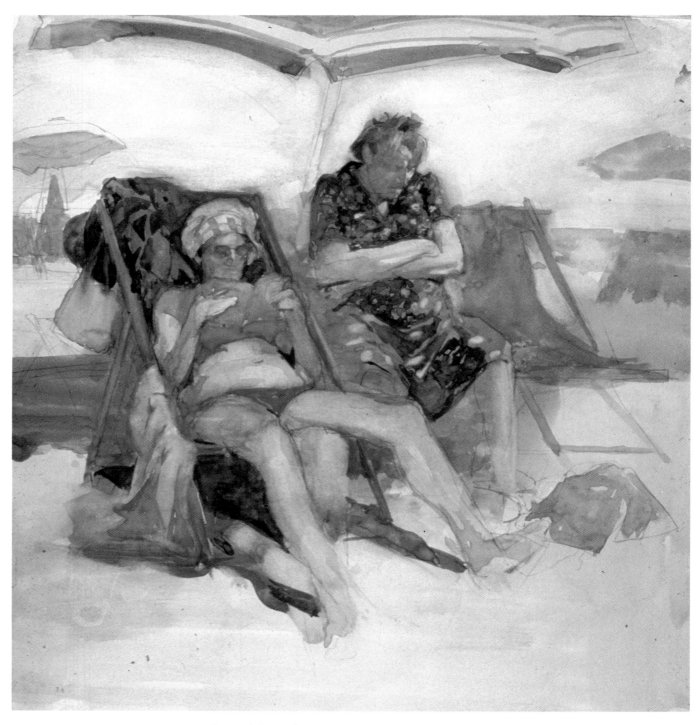

Stage 4: Now for some small touches and refinements. I put a new umbrella in the background and I add weight to the woman reading. There are also suggestions of features and hands. But something is beginning to disturb me. I have the sense that this isn't adding up to the massive quality I had in mind. And I'm not happy with the left background. I feel it's too empty. I want the figures to emerge from a cluster of medium dark shapes. I also fret about the fact that the reading figure seems too separate, too isolated.

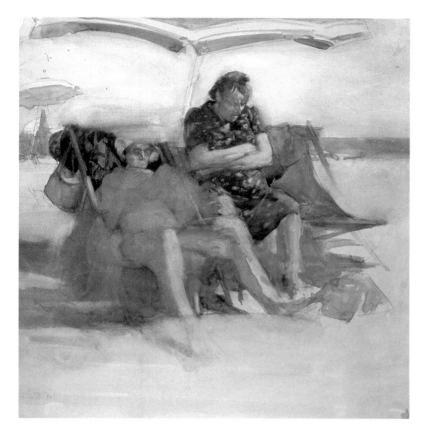

Stage 5: I decide to wipe out all of the figure on the left. (This photo shows the beginning of this erasure.) I rub gently with a fairly damp kitchen paper towel. I also lay a gray wash over the center of the torso to allow me to model the new figure. This wash obscures the old form and also provides a local ground tone out of which I can pick new lights and darks. At this point, I've got to be careful about the paper getting roughened or feathered. I've also got to be patient and wait until the wiped out surface is thoroughly dry before I apply the new color. (I can hasten this with a hair dryer.) If I don't let the paper fibers dry and harden, the softened fibers will absorb the new color and inhibit further wiping out.

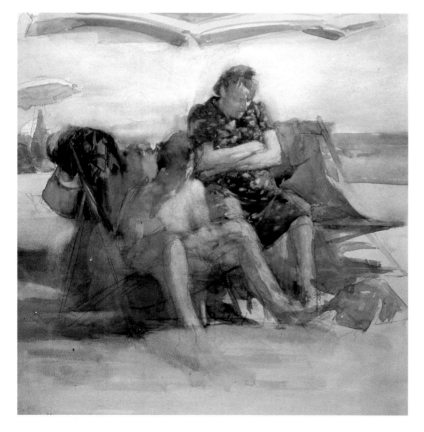

Stage 6: I decide that the new figure should be more active, even though she's seated in the sling chair. I lightly draw in the new shapes. With a wet brush and the dampened tip of a paper towel, I wipe out the light areas of the form—shoulder, head, legs, etc.—and then I add warm washes to build a very quick sense of light and dark. Now to the head. Here I must be careful . . .

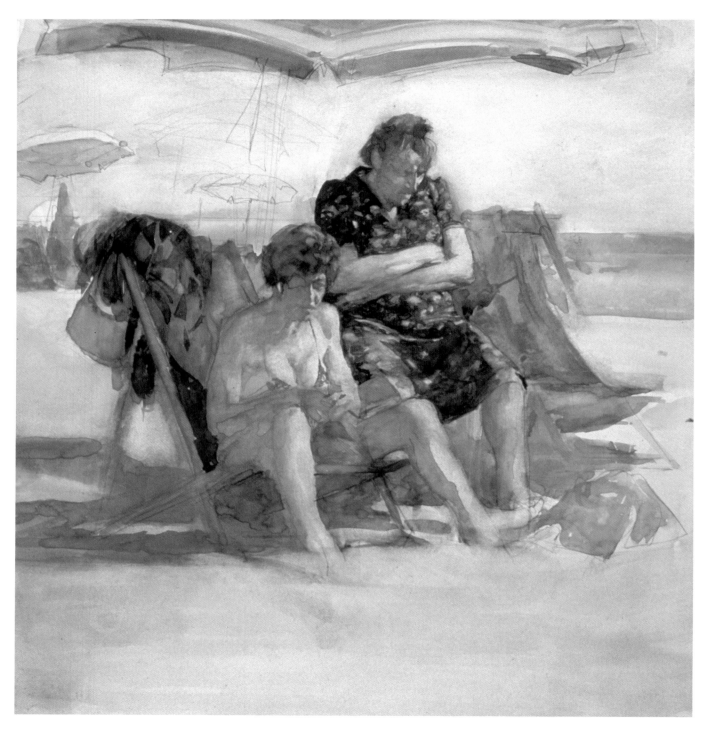

Stage 7: I want her head to look up from knitting—squinting through the sunlight glare. At the same time, the face should be nonspecific, almost impressionistic. In a photograph, I find a face that fits the same light effect and has a sort of half frown because she's squinting. Now I find that something else has happened. The forward movement of the body and the facial expression have combined in an unexpected way to produce another nuance—a feeling of anxiety. Now the side-by-side relationship with the older woman takes on a sudden poignancy.

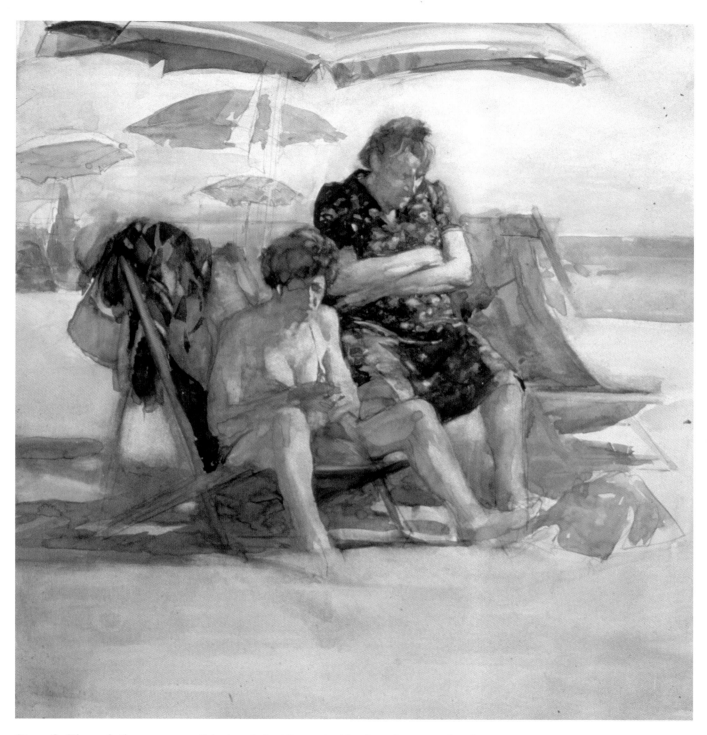

Stage 8: The painting seems well in hand, but I must add other shapes and refinements. I paint in more beach umbrellas and finish off the one directly above the two women. I've got to sharpen up legs, beach chairs, and other assorted items that seem fuzzy and weak. As I work, I feel fretful again. The printing is getting too busy, too laden with facts. The beach chair to the right of the signora—the older woman—seems pointless and repetitive in shape, color, and thrust. At the moment, I hate it, but I decide to leave it for a few days.

Stage 9: Thinking back to the early stages of the painting, I feel that the energy and directness of the original idea have been vitiated, even with all the positive changes. The configuration—the color and shape—of stage 2 had so much greater impact! I decide to eliminate the right-hand beach chair, extend the ocean behind the figures to add a feeling of expanse and emptiness, and broaden the blue patch for its color. The signora's dress has gotten terribly fussy. I paint back into it with a simple, grayish black, sharpening and redefining the hunched shape of the figure. Now I can indicate the print pattern by simply picking out a series of grayish spots. I'm getting close to the finish.

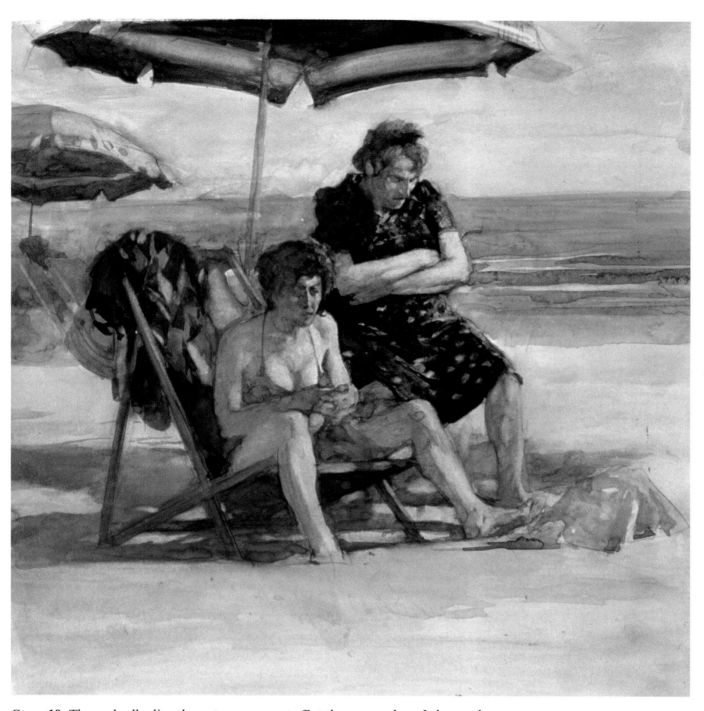

Stage 10: The umbrella directly on top seems cut off at the wrong place. I change the drawing so the umbrella is seen from underneath. This is a more interesting shape. I also eliminate the other umbrellas, keeping just one on the left to establish a middle distance. Now I deepen the color of the umbrellas and tidy up some muddy passages in the hands and feet. I'm feeling much more positive now. I'ts a small painting, but I find it satisfying because of its interactions. In the back of my mind lurks the thought that I'll do it again, much larger. One thought keeps returning to me again and again as I finish the painting. It should have the same sense of discovery at the end as it did in the beginning. The total image ought to have the same force, the same sense of visual excitement. *The Signora*, painted in 1981, is on a 10″ × 14″ (35 x 35 cm) sheet of plate bristol paper.

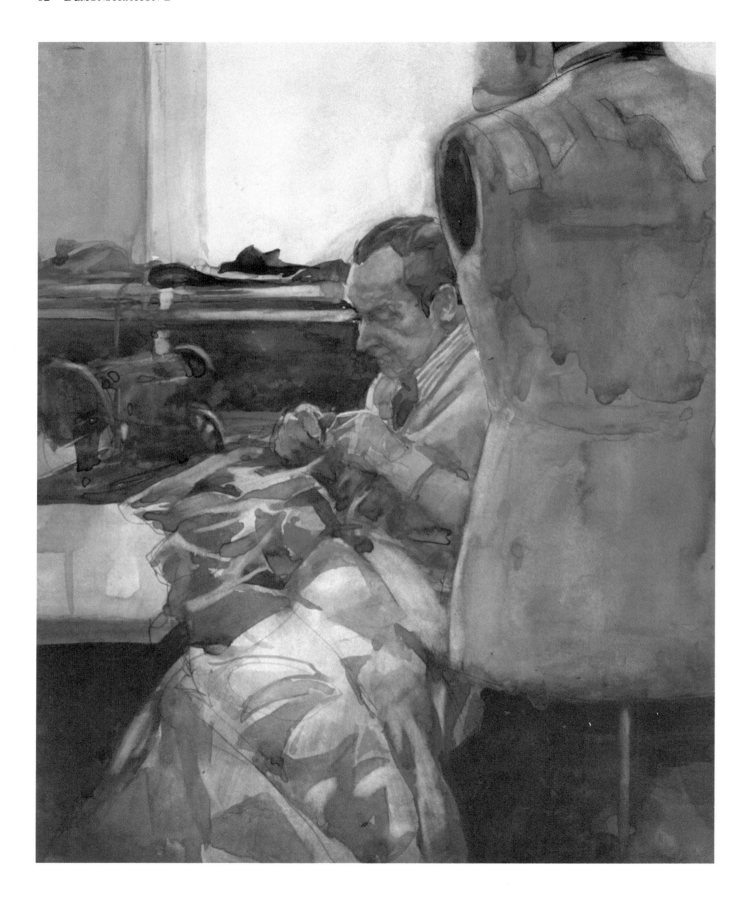

The Tailors

From the very outset of my painting life, I've done pictures of people at work: upholsterers, women ironing, construction workers, garment workers. The subject continues to touch a responsive chord in me. Sometimes I fear that I'm just romanticizing the *idea* of work, like the Pre-Raphaelite artists who painted sentimental pictures of noble workers and "honest toil." But I'd like to think that I'm a bit tougher and a bit more realistic in my view of work. I think my affection for the subject is linked to respect for people who work with their hands and who are good at it.

After my last series of pictures of laundry workers in Italy, I felt that I was finally done with this subject. I swore: "No more damn ironing boards!" So I was surprised—if not dismayed—to find myself working on the theme again. But then I reminded myself of my friend David Levine's comment when I expressed surprise that he was going back to paint at Coney Island for what seemed like the hundredth time. "Well," he said, "I just have to do it until I get it right." These new pictures were derived from sketches I made when I was commissioned to draw the backstage operations of the Metropolitan Opera in New York, where I was fascinated by the costume shop.

I wanted to be objective in my depiction of these workers and to see them without sentimentality. However, when I was doing the drawings, I had a flashback to the time when I was a kid, carrying our

(left) ***Mending a Garment,*** *1980, watercolor on plate bristol, 15″ x 11″ (38 x 28 cm), collection of Mr. Edward Sindin. The central idea in this painting is the image of the tailor viewed behind the massive, looming bulk of the dressmaker's dummy. I think the cut-off view and the sudden change of scale—the big dummy in the foreground and the smaller figure of the tailor beyond—lends drama to the picture. I'm pleased that the figure of the tailor, hunched over in his typical working posture, seems strongly realized. The tools of his trade crowd in on his small, isolated world. The design of the picture and its emotional content really seem to match.*

soiled garments to the tailors for cleaning and mending. I was always a bit afraid of these old men because they were usually gruff and unpleasant, muttering and grunting in response to my querulous requests for service. They snatched the clothes from my hands and then returned to their hunched postures. The contemporary tailors at the Met—union-supported, pension-funded, and comparatively secure—nevertheless reminded me of the shabby tailors of my youth, tired and irascible, mutely enduring the endless flood of soiled dresses, torn skirts, and shiny trousers. Immigrants working far into the night and dreaming of a better future for their kids.

From the very beginning, there were some problems of conception.

While I felt that the environment of the costume shop—with its dizzying array of costumes and bits of materials—was critically important in the picture, I also wanted to focus on the character of the tailor himself, almost to make a portrait of him. So the question was *what* would dominate the image? And this was further complicated by the presence of the dressmaker's dummies, which I also wanted to include because of the strange sense of mystery—or was it anxiety?—that they induced in me by their headless, humanoid shapes, and their mute lifelessness.

After making sketches, I returned to the costume department again to take photographs and to experience the scene once more in hope of sorting out the direction that the painting would take. I did feel one thing for sure: I would want to paint it in watercolor. For starters, I felt that watercolor would enable me to render the multitude of objects—materials, patterns, etc.,—with greater ease and more emotional effect, than with oil. I also felt that watercolor had a special character—the capacity to depict the subject clearly, yet remain elusive—that was especially right for the ambiguous feeling I wanted in the painting. Finally, I felt that watercolor was right for the tricky lighting in the shop. There was fluorescent lighting overhead and daylight coming through the windows behind

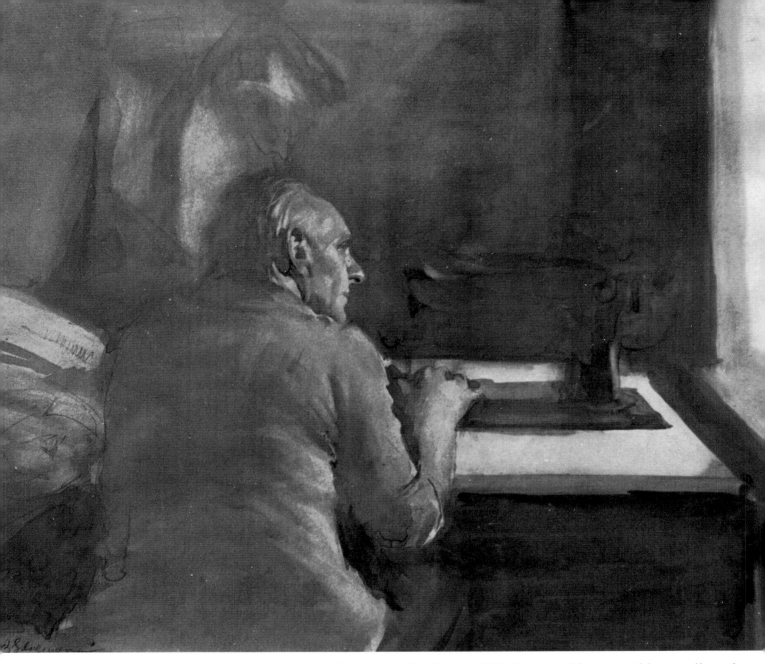

The Old-Fashioned Machine, *1976, watercolor on plate bristol, 14⁴″ x 15⁴″ (37 x 40 cm), collection of the artist. I did several paintings of this man, who posed in my studio, working at an old dressmaker's machine acquired from a friend. This was one of an ongoing series of pictures devoted to the theme of people at work. At the time, I was dissatisfied with the picture and stopped working on it without finishing the whole right side. Despite this limitation—or perhaps because of it—the painting does have a rather strange appeal. The right side drops away into shadow, which dramatizes the head and figure that pick up light from the window.*

the figures. I felt that I could capture this complicated lighting effect more easily in watercolor than in oil.

After a number of false starts, I decided to worked on a full-size sheet—22 X 30 inches (56 X 76 cm)—because I thought the theme deserved a large scale. Most of my watercolors are a lot smaller, but I must confess that I'd fallen victim to the competitive impulse to match the bigger watercolors that so many artists have been exhibiting.

I felt excited—and not a little bit insecure—at the prospect of splashing around on a sheet of paper that seemed like a football field compared to my usual scale. I wondered whether the picture really merited this large scale, or was I simply indulging in size for the sake of size? I also wondered whether the paint would work as effectively on such a big sheet of bristol paper.

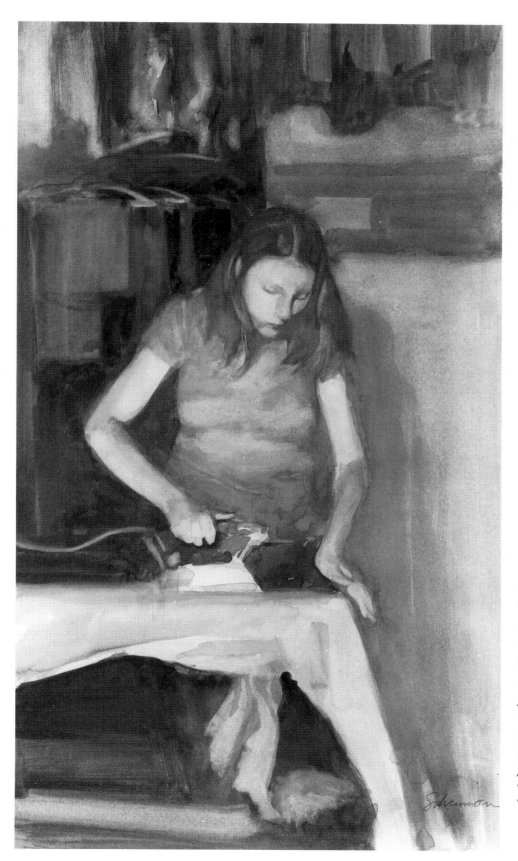

Handwork, *1974, watercolor on plate bristol, 19″ x 11″ (48 x 28 cm), private collection. My long search for materials and methods was finally justified by such paintings as this one. The quality of the paint, the rendering of the forms, the color—they all flowed together with ease in this watercolor. Contrary to so many of my recollections about past work, this picture seems to have been problem-free. Although the painting wasn't really intended as a study, it later served as a study for a large oil.*

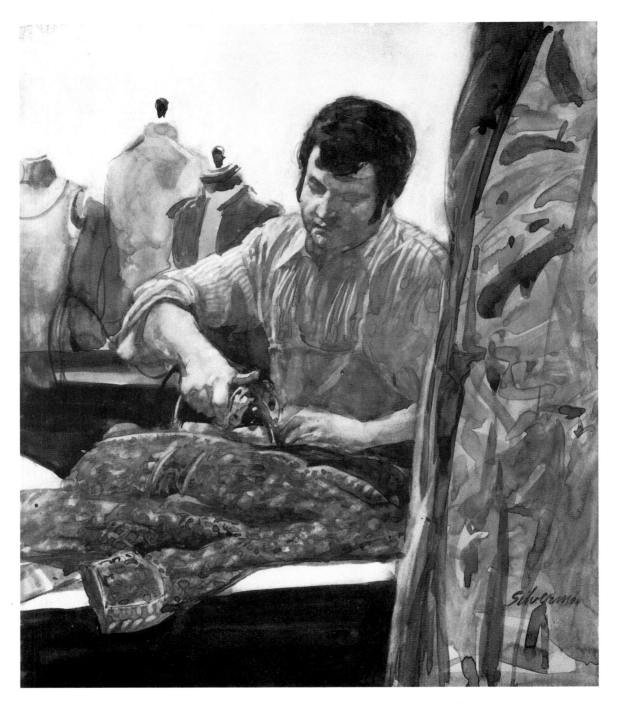

The Finisher, *1981, watercolor on plate bristol, 13" x 11" (33 x 28 cm), collection of the artist. As so often happens with many artists, one picture spawns half-a-dozen more. Very soon after I completed the demonstration piece, I painted this small picture, which incorporates many of the ideas I talk about in my commentary on the demonstration. It also combines two of my favorite themes: tailors and women ironing. Once again, I was interested in the interplay of the flat, decorative patterns of the fabrics and the modeled areas of the figure. The flat, dark shapes in the foreground and the bare, pale shape of the wall behind the dummies are important because they provide relief from the more active patterns of the fabrics.*

(above left) This little pencil drawing was my initial response to the character of the costume shop, which later served as a stimulus for the demonstration painting, and for others as well. The drawing was very rapidly done—no more than a couple of minutes—with quick, scribbly strokes for the darks.

(above) When I went back to the costume shop again, I made this more careful study of the two tailors who eventually became the subjects of the demonstration painting. At this stage, I was beginning to anticipate the graphic importance of the patterned materials, which would get even greater emphasis on the watercolor to come. And the composition was beginning to emerge more clearly.

(left) Here's another view of the two figures with the dressmaker's dummies, but this time with garments on the dummies. I didn't use this composition in the demonstration painting. But I did use part of it in the painting of the Two Tailors, *reproduced on page 42.*
This sequence of three drawings is fairly typical of my method when I'm working on a complicated composition. That is, I start with one or more quick pencil sketches, and then I do more careful studies on a larger scale before I start on the painting itself.

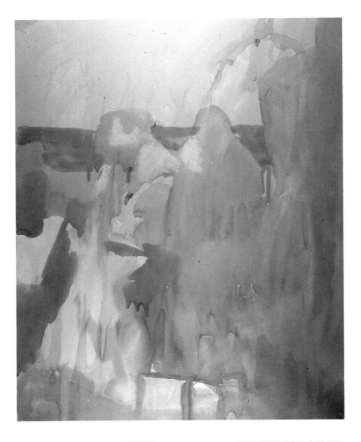

Stage 1: It takes me some time to find a big enough piece of Masonite to tape down the paper. Then I use a large, mop-like brush to apply broad, wet strokes of gray and ochre, containing some opaque color. I begin to paint the forms of the two figures, drawing with the paint, and mapping out the placement of the garments, floor, and dummy. Everything looks wet and weirdly unfamiliar.

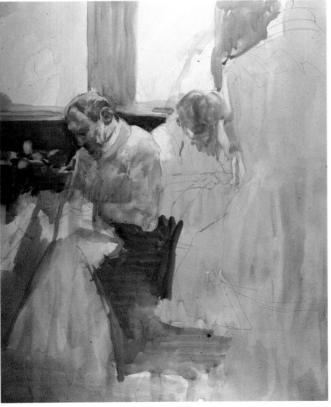

Stage 2: When that first layer of color dries, I pencil in the two tailors and the looming form of the dummy. I add gray-green patches for the darks, and I model the head sunken into the chest. I decide that the tailor on the right will be younger and more contemporary-looking, and I add the darks to his head. I'm having difficulty deciding whether to sit or stand. When I sit, I'm too close, and I lose my sense of the total picture. When I stand, I have to reach too far out and down, and I lose some control over my brushwork. So I solve the problem by alternating, sometimes sitting and sometimes standing.

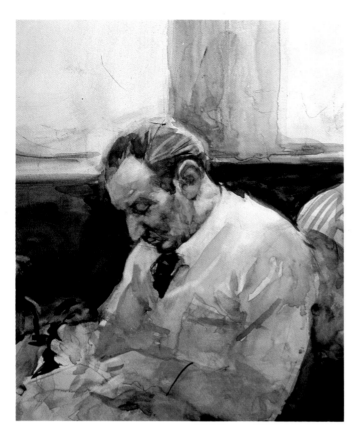

Stage 3 (detail): As I get into the details of the older man's head and body, I'm having trouble getting the set of his bent form. He seems stiff and unconvincing. Maybe if I move his arm forward, this will give a more characteristic slouch to his body. I lighten the gray, rectangular shape behind the head because the form seems too heavy. But I have the feeling that I'm going to have to change that whole section at some point later on.

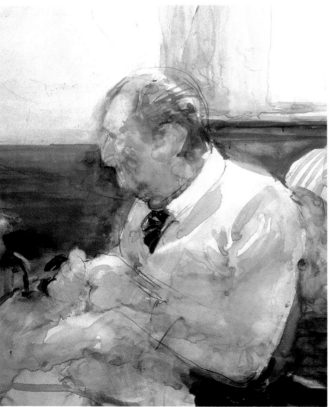

Stage 4 (detail): I decide to make some important changes, but not without problems. For some reason, the paper seems more absorbent than usual, and I can't remove as much of the old paint as I'd like to. The paper is also badly buckled and won't stretch back to a smooth state without a lot of drying time. I wait for the paint to dry, and then I add new drawing lines over the areas that I've rubbed out. This means the arms and hands, as well as the head. I feel better now. This looks like the right move.

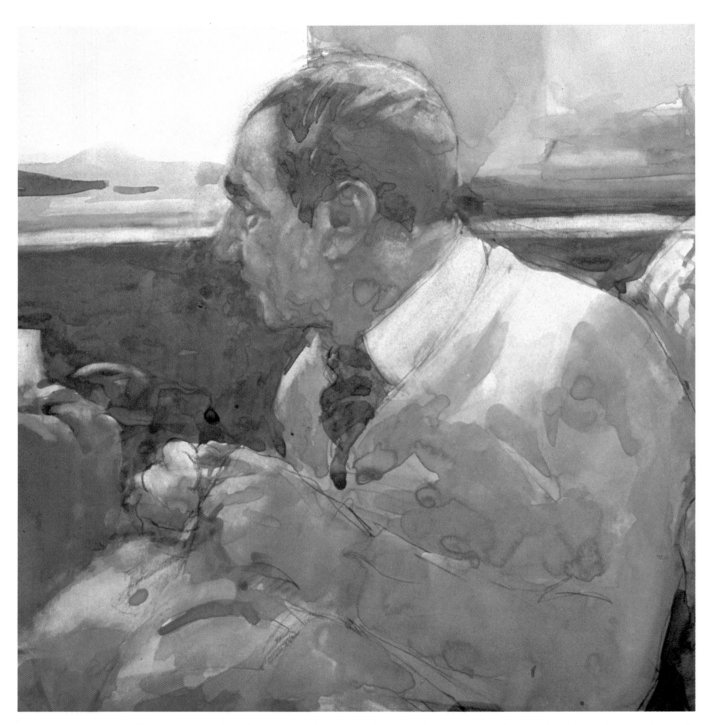

Stage 5: (detail): I still have my doubts about the painting and I take a two-week break. (Sometimes I think I hate watercolor!) I go back to work on the older man again. I rub him out again and start over on a head that looks up, not down. I add definition and dimension to the head by deepening the grayish lower area. I paint the ear—which I've always loved to paint since I was a young student and saw a Degas profile with a gorgeous ear! Next I model the torso and sweater with more gray washes, leaving a light area at the shoulder. I work on the hands with a mixture of vermilion and Naples yellow, letting the brush follow the curl of the fingers. While the hands are drying, I rub out some small sections near the arm and shoulder. Then I go back and lift the lights on the tops of the fingers. The forms are still rather crude, but the refinements will come soon enough. I often make the mistake of developing some forms too quickly and too fully. Later on, there's time to decide about the small details.

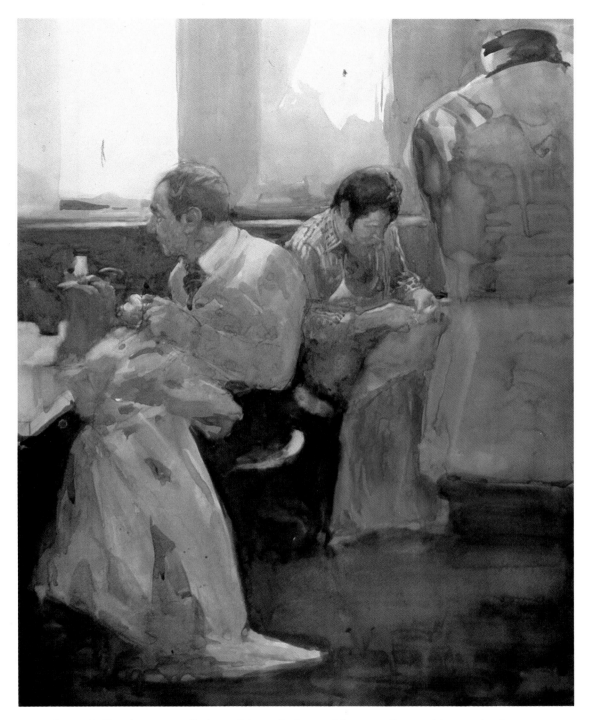

Stage 5: Here's an overall view of the painting at this stage. I'm working on the figure at the right, alternately painting, rubbing out to get the lights, and then adding more color. I'm developing the pattern on his shirt and I sharpen the shape of his hair, giving him sideburns. I define the dark patches of the wall and floor, develop more color on the garments in the tailors' laps, and begin to suggest the details of the sewing machine at the extreme left. The shape of the dummy also starts to emerge, although the paint still looks loose and runny. Some jagged strokes suggest reflections in the central window.

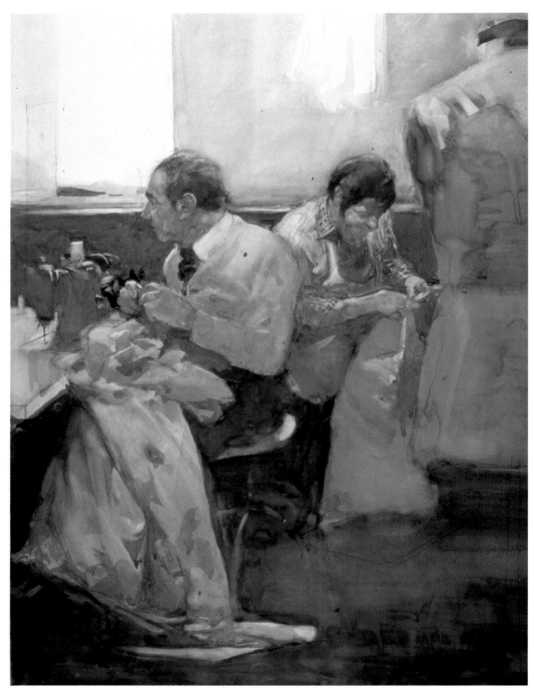

Stage 6: The paper has gone through enough wet and dry cycles to change the surface so that the paint sets more easily, developing a more pleasing quality so that it really looks like paint. But there are still problem areas. I decide to remove the window in the upper right and make this a pale green wall with a light patch that I'll develop into the hanging paper patterns used in garment shops. I'm still working on the head of the second figure. I also rub out and redo the shirt, painting the form first, without decoration, to get the modeling right, then adding the pattern on top of that. (Once again I realize that a watercolor can take as much time as an oil painting, at least the way *I* handle watercolor.) I do some more work on the garments on the tailor' laps, adding more color to the red one, scrubbing it to simplify the shape, and then adding more color again. I'm also sharpening up the head, and especially the hands, of the figure at the left. I fuss with the dummy, scrubbing the shoulder to model the form, which I want to be heavy, but somehow misty and mysterious.

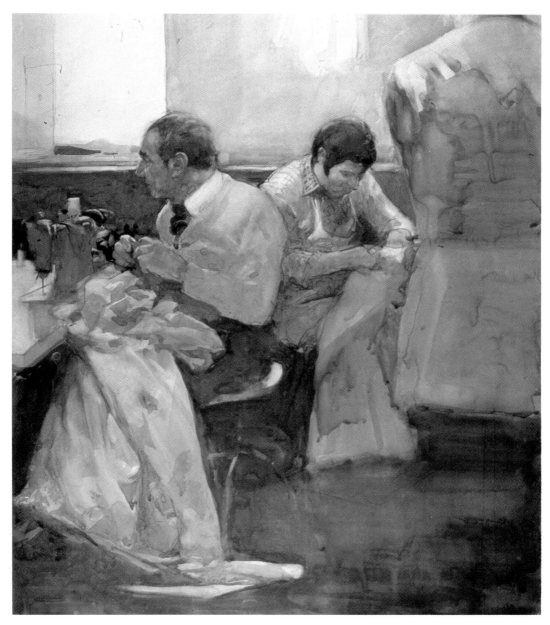

Stage 7: Other plans, other paintings, some free-lance assignments—so I leave this picture for almost three months! Now I start again, spending the first half hour trying to retrieve the mood and trying to decide where to begin! Just to get going, I work on the costume at the left with a combination of rubbings and warm sepia washes. I want to pull together the tangled surface of the cloth so that it has texture, yet lies flat. I'm especially interested in preserving the shape of the end of the fabric, lying on the floor, almost like a pool of water. The patterns of the pale green floral shapes follow the contours of the folds. Back to the hands again, where I add dark accents to the fingers and around the contours. The sewing machine requires definition. I redraw the contours with a charcoal pencil, and then I pick out the lights with a brush. Around the machine, I rub out the lighter portions of the table to define the machine. This

is a device I employ frequently—defining a shape by wiping away the negative space *around* it. This technique preserves the luminosity of the surface and keeps the painting alive by varying the texture of the paint as I work on different objects or materials. (Thus, I could have painted that whole fabric green and then wiped away the areas around it to make the patterns.) I still feel that the second tailor's head, features, and hands seem clumsy and lumpy. I do some more work on them and add more color to the face, especially the nose. But where's the light source—where does it come from now that I've closed off the window? I wipe out some of the color in the cloth and add some highlights, but this still seems wrong. To get it right, I'll have to set up a piece of silky cloth, arranged to the right shape, and then I'll paint this from the model.

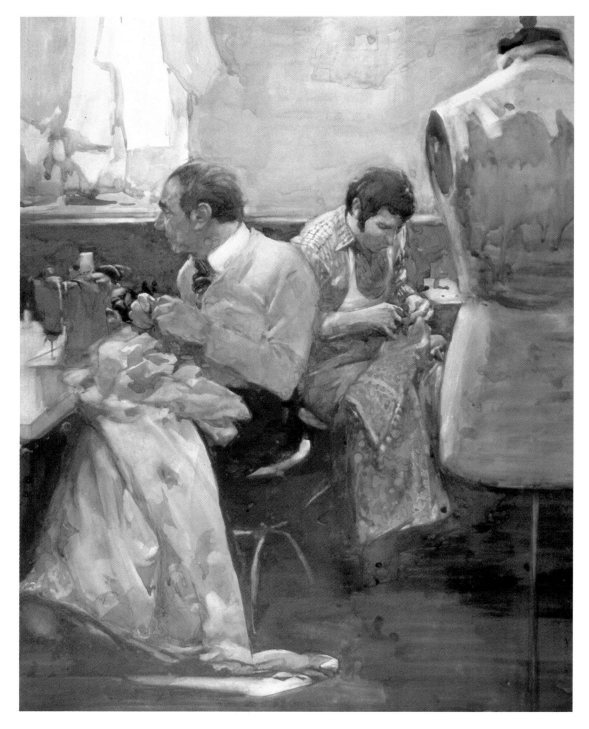

Stage 8: Still working on the figure at the right, I float a new wash of color over his shirt and down around the apron. I work on the face and hand by alternately wiping and painting, then adding dark accents to define the shapes. With a small, wet sable brush, I lift out the pattern of the shirt. I do some more work on the hands, adding warm color and defining the shapes so that they seem to fold into the garment or just emerge from it. I repaint the garment on his lap so there's a printed design on the fabric. Now I've got the shape, color, and texture right so that the garment stays back, but is still an active form. The dummy is last. By rubbing out some more of the drips, just enough to blur some of the strokes, I get that vague, bulky mass that I want.

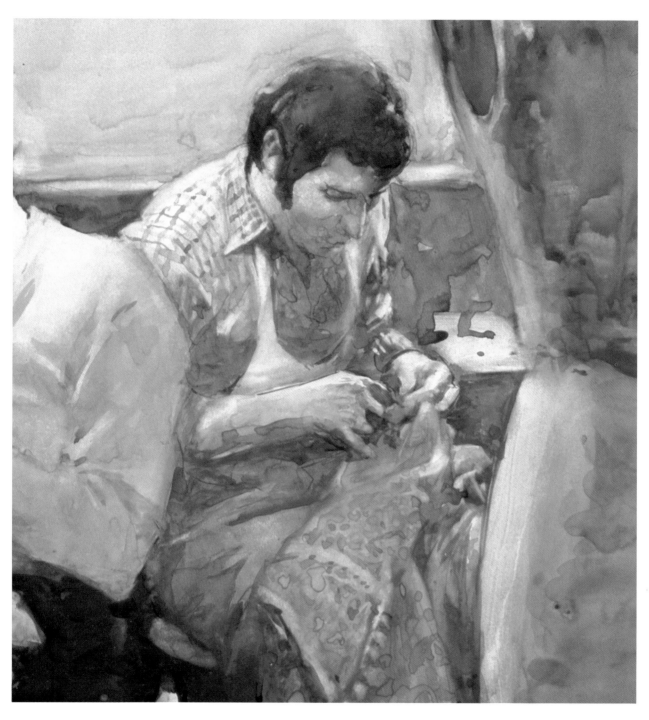

Stage 8 (detail): Here's a closeup of the second figure. You can see how I paint the patterns of his shirt and the garment in his lap right over the broad tones of the modeling. The dark accents are applied selectively—not all over the place—to define his face and hands without too much detail. I've also redrawn the arm on the right so that it's tucked in close to his body. This gives the figure a tighter, more solid feeling, and also does a better job of suggesting the feeling of his involvement in the work. All those little puddles and dribbles give the painting a lively, spontaneous feeling, despite the long, slow work that took so many months. *The Tailors*, finished in 1982, measures 22″ x 29″ (56 x 74 cm), after trimming just a little bit off the top and bottom. It's on plate bristol paper.

The Down Coat

For more than twelve years, I've conducted small, weekly classes in my studio, where my students and I share the experience of working together from a model. When professional artists teach, they often say that they learn as much from their students—if not more—as the students learn from them. And this is often true for me.

Out of these classes have come a lot of my paintings that can be roughly called portraits—not in a conventional sense, but simply because they're pictures of people. As with any repetitive job, the challenge of inventiveness becomes more acute. I try to pose each new model in a new way, and with fresh combinations of lighting and gesture. Nevertheless,

(left) ***The Silk Scarf,*** *1980, watercolor on plate bristol, 22" x 15" (56 x 38 cm), collection of Mr. Joseph Montuoro. Like most of the paintings in this chapter, this one was also executed in my studio class and it's something of a favorite of mine. All the components of the picture work together in a kind of curious counterpoint, reinforcing the ambiguous characterization of the model. The caricatured elements in the face jar with the grave, wistful gaze. The costume gives some hint of elegance, but the model's posture and the rendering of her garments seem slightly frayed and out-of-kilter. Finally, the brushwork is both precise and suggestively loose.*

some measure of repetition is inevitable, as you'll see in a number of the paintings shown here. However, while they're similar in pose, they're often different in their content—because of differences in mood, atmosphere, personality, and other subtle aspects of character.

This demonstration painting—a young woman enveloped by her coat and scarf—bears a strong relationship to a number of my other paintings in which the clothing is used both as a decorative device and as a way of suggesting a person's temporary isolation from the world. In all these paintings, there are also differences in the subject's facial expression—wistful, withdrawn, even angry—and the face of this particular model had its own special mood.

This young woman's pose was strongly influenced by the many different layers of clothing that she wore to keep herself warm on a particularly frigid day in the winter of 1981–1982. The clothing also provided a marvelous patchwork of items that didn't really go together, and were pleasing for just that reason. It was a challenge to make it all hang together in a convincing way. I also found the model to be a most engaging subject because of her personality and her looks: chiseled features, capped by a strong nose. Especially in profile, her face was forceful and poignant at the same time. I set to work with enthusiasm.

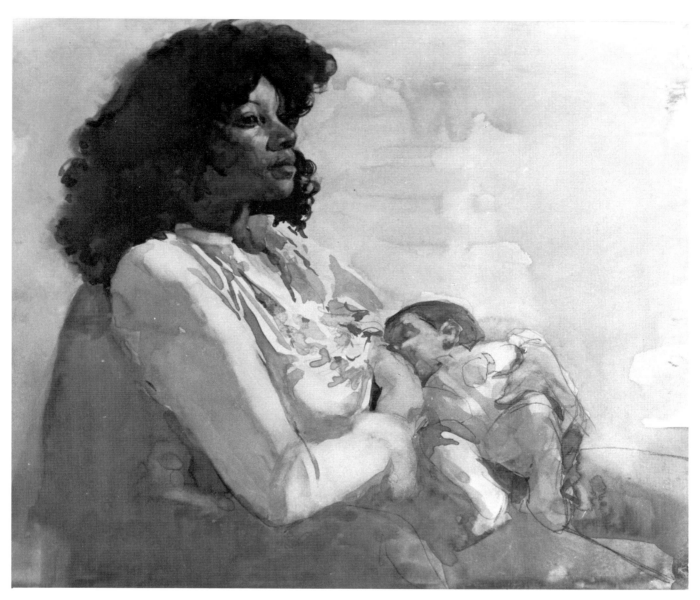

(left) **The Pink Robe,** 1970, watercolor on gesso-coated watercolor board, 16″ x 8″ (40 x 20 cm), collection of the artist. This painting was done when I was still struggling with various surfaces and having my problems with that gesso-coated board. I remember this picture because things really went well for a change, and I could finally say to myself, "At last I'm doing a watercolor!" The pigment seemed to go where I wanted it to go, and the washes remained manageable throughout the painting. I think I also managed to overcome the rather hackneyed pose of a figure with a hand supporting the head. The painting seems to work because it is, in fact, highly abstracted in the rendering of the forms, and because of the graphic drama of the jet black hair.

(above) **A Woman Nursing,** 1980, watercolor on plate bristol, 10″ x 14⁴‴ (25 x 37 cm), collection of the artist. I was intrigued by the lyrical lines of the pose: the curves and angles of the mother's hair, arm, and hands, and the curves of the baby's body. The curves contrasted with the overall passivity of the mother and child. As I painted, I must confess that I was also worried about whether the baby would stay at her mother's breast for three hours! The richest modeling is in the two heads, while the bodies are painted much more simply and the chair is merely indicated by a broad, irregular tone. I fear that this painting will stay in the drawer of my blueprint cabinet for a long time. Somehow, the image of a woman nursing brings out the most negative responses in potential collectors.

Standing Figure, *ca. 1974, watercolor on clay-coated paper, 14" x 9½" (35 x 24 cm), collection of Mrs. Nancy Acheson. The clay-coated paper turned out to be best for simple images like the one shown here. Most of the rendering was done in the area of the head, where I was working in small patches and didn't have to worry about controlling large areas of color.*

An Israeli Girl, *1978, watercolor on plate bristol, 15″ x 13″ (38 x 33 cm), private collection. This model projected various contradictory qualities that were apparent all at once: composure and agitation, recititude and sensuality, self-absorption and sensitivity. I'm not sure that any of these qualities come through. But I'm conscious of having used specific details, such as the alert, yet distant facial expression, the turbulent pattern of the bedspread, the raised leg, and the strangely stiff hand to suggest her anomalous personality. Of course, these observations are after the fact. My response is much more intuitive when I'm painting. But if my antennae are well tuned that day, I pick up the right signals and the significant details emerge in the process of painting.*

Stage 1: Making sure that I'm in the right position in relation to the pose, I begin by massing in my colors on a strong right-to-left diagonal. I start with a blue-gray color that seems to be the dominant underpainting for the image. The patches of purplish red (for the coat) and the pale orange (for the head) are added very soon after. This initial phase, as in most of my pictures, happens quickly. In the present painting, it takes less than ten minutes.

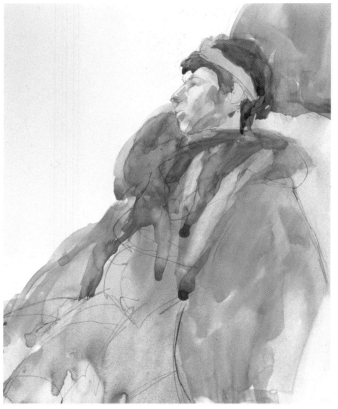

Stage 2: Now it's just twenty minutes later. My students are painting around me and I take a few moments to make some suggestions. Far from being distracting, this helps me in my own work—helps me to decide where I want to go with my own painting. The first stage is thoroughly dry, and now I make a rapid pencil drawing right over it. I do some rubbing out in the face, and add dark ochres for the hair. I begin to do some modeling on the face. Some large, rapid strokes suggest the shape of the garment around her neck. I also strengthen the dark behind her head—in the upper right-hand corner. I'm feeling impatient and I want to get everything down quickly. I don't want to wait for the paint to dry, but I've got to, so I stop again to talk to some students.

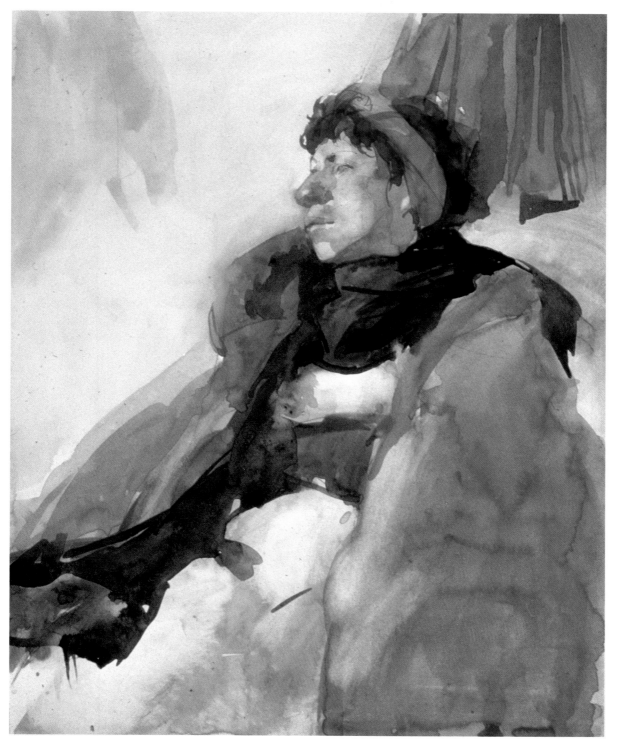

Stage 3: I'm beginning to work over the whole image now—a half hour after stage 2. The features of the head and the broad darks of the scarf and black sweater are added rather loosely. Alternately, I'm wiping away the lights in the head and then building up the colors. Along the sides of the big shapes, I begin to wipe away some color to define the silhouettes. The model is also wearing overalls, where I do some wiping. I don't feel quite right about the head yet. It doesn't have the kind of arched pull from the neck that would help to activate the pose. Even though it's a figure in repose, that pull would give a special urgency to the features in profile.

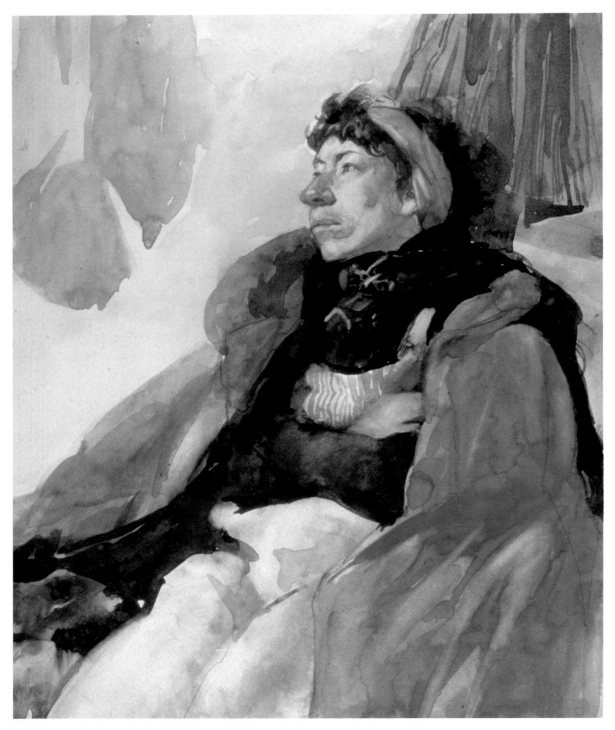

Stage 4: Another twenty minutes have passed and I'm concentrating on the upper torso, building more variety into the modeling of the head and the surrounding textures. Dark accents pick out the hair and features. I also define the filigree pattern on the scarf and then reinforce it by floating in more blacks and a blob of red. The collar gets similar treatment. With a small, pointed brush, I float in stripes on the cloth that hangs from a nail behind her head—where there was just a dark patch before. I'm also adding darks to model the folds in the coat.

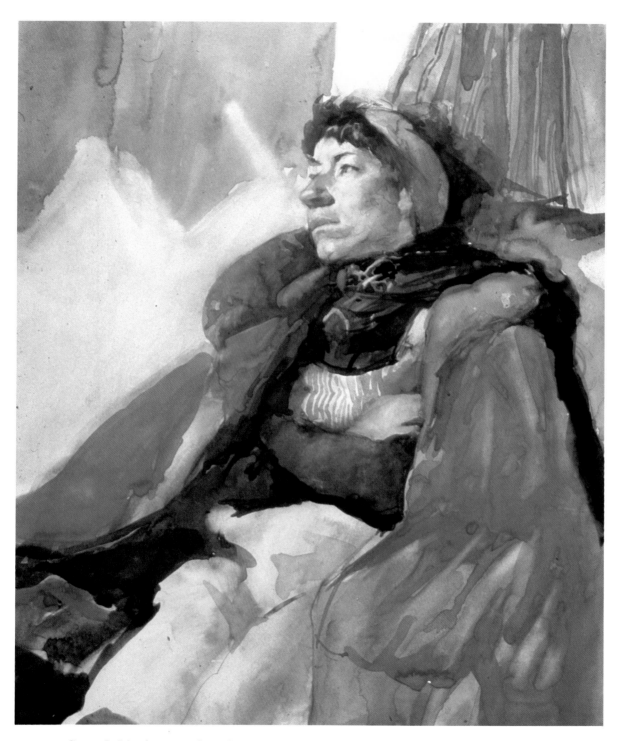

Stage 5: It's almost an hour later and I'm hopping around the class, looking, talking, thinking, and also painting. From another vantage point in the studio, I get the notion that I'd like to bring a dark closer to the model's head to heighten the feeling of light striking her profile. So I move in the dark from the upper left. I add more washes of color to bring up the puffy volume of the coat. This seems important to the pose: pleated volumes of comfort and protection. I'm still working on the head, which isn't difficult to paint, but I can't seem to get it to "turn" properly. The repeated washing out of colors and shapes has begun to make the surface look a bit weary.

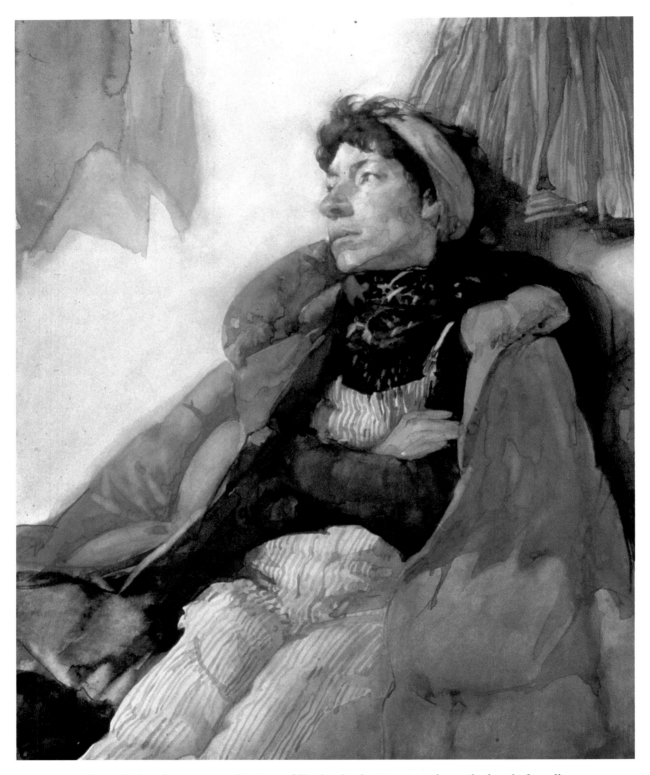

Stage 6: Another twenty minutes and I'm beginning to get a grip on the head after all. With some more wiping and repainting, I narrow the distance from the nose to the cheek and add more hair coming down the side of the cheek. I brush in a simple gray wash on the side and allow it to puddle into a hard edge, strengthening the cheekbone. I wipe out some of the strong reds in the nose and add a grayish blob to the side of the nose, as I did along the cheek. This is just Payne's gray and some white. I redraw the eye with a brush line and pick out more of the pupil.

Stage 6 (detail): In this closeup, you can see how I get into the scarf around the head and wash out some of the dark of the hairline, so this fuses with the cast shadow behind the head. This helps me to obscure the edge of the material hanging in that upper right-hand corner. The coat seems too active now, and I change my mind and remove the cast shadow on the wall to the left of the head. I finish this stage by adding the rest of the stripes on the overalls.

Stage 7: The painting seems okay. But, as usual, I have second thoughts. I wonder whether I really need that fabric at the left, and its shadow. The hand in the crook of the bent arm also seems rather frail to me now. In my first rush of enthusiasm for painting this model, I thought that this painting wouldn't be a problem. The simpler the image, the more significant is each detail. I'll have to do some more work on it after all. *The Down Coat*, painted in 1981, is 12″ x 15″ (31 x 38 cm) and is done on plate bristol paper.

Stage 7 (detail): With about ten minutes more to the pose, I add more planes of color to the head. These are tints and washes of pale pinks and blues. The transition from light to dark on the head seemed weak. I hope it's better now.

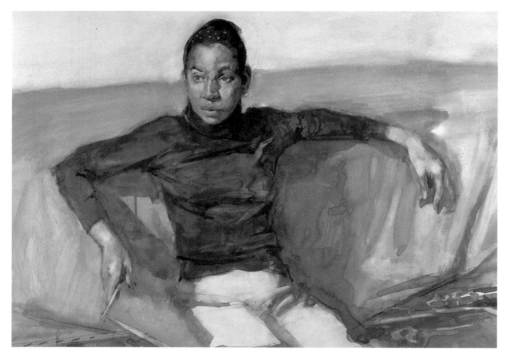

Crowlie, *1981, watercolor on plate bristol, 14″ x 21″ (35 x 53 cm), collection of the artist. This was my first version of the painting, which I left unfinished. I remember feeling terribly frustrated by the fact that I'd done this picture under "duress." I was working under pressure in my studio class, and sitting in the wrong spot. One of my students was actually sitting in the right spot, just ahead of me, from which the pose was really much stronger. I took a photograph of the model from the better angle, intending to repaint the picture later on.*

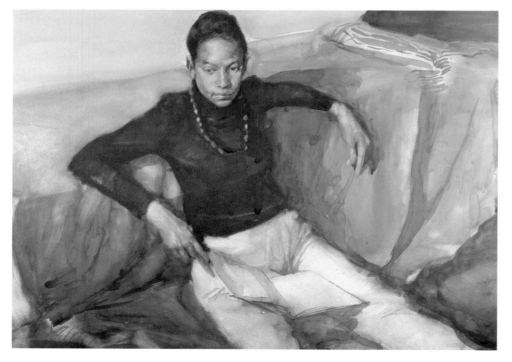

Crowlie, *1981, watercolor on plate bristol, 14″ x 21″ (36 x 53 cm), collection of the artist. A few days later, armed with the photograph I'd taken at the end of the pose, I set about changing the painting. I was hoping to wipe out and alter just a few elements, including the perspective of the couch and floor, thus providing a more downward view of the figure. But I ended by repainting almost everything. The special character of the bristol paper, lending itself to extensive wiping out, allowed me to do all this over the first version. The resulting picture is far more satisfying, I think, with its tilted view of the figure, the more interesting angles of the arms, and the diagonal pitch of the background shape.*

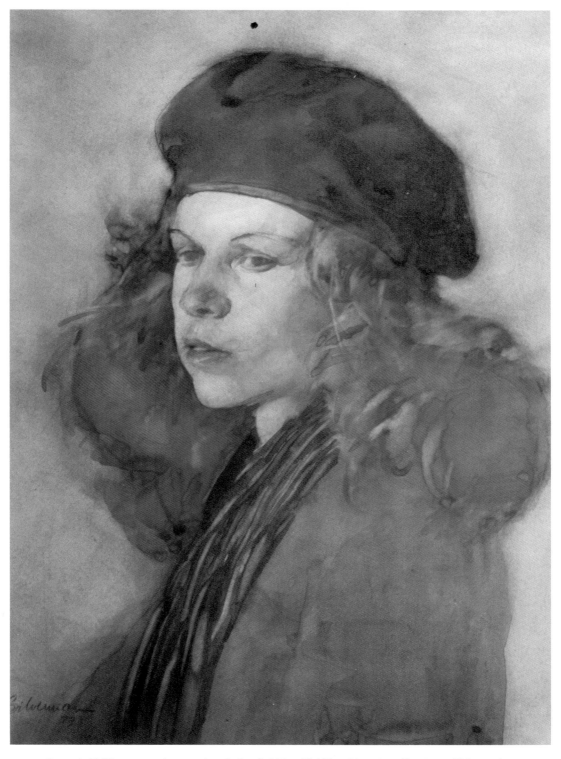

Jacqui, *1980, watercolor on plate bristol, 13″ x 9″ (33 x 23 cm), collection of Mr. and Mrs. Ronald Abramson. Looking at this watercolor, I'm reminded of something I read in an article about Andrew Wyeth. He was quoted as saying that when he painted a picture, he wanted to get at the utter* realness *of things, to grab hold of it and preserve it with his art. Something like this same viewpoint comes through in the work of Thomas Eakins. While this painting isn't indebted to either artist, I think it reflects the same intention.*

A Black Shawl, *1978, watercolor on plate bristol, 15″ x 11″ (38 x 28 cm), collection of the artist. This is the picture I mentioned earlier—the one that so resisted my efforts to turn the face into a less disagreeable expression. For several years, I had difficulty deciding whether or not to destroy the painting. Now I've grown fond of her, and the painting hangs in my home. There is, after all, something pleasing in the way that troubled face is framed with the big shape of her hair, merging with the dark shawl. It's the simplest kind of design for a portrait, and it works here to alleviate the insistent, depressive mood of this young woman.*

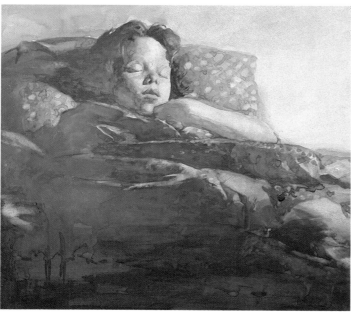

Sleep, *1981, watercolor on plate bristol, 13″ x 15″ (33 x 38 cm), private collection. This is a portrait of my son, Bobby. I tried to steer a delicate path between objectivity and sentimentality. I was worried that the picture might become too sweet—overcome by the parental affection that always surfaces so strongly at night, when you see the kids sleeping. The small nightlight, next to his bed, gave off a warm glow that cast his face in a beautiful array of lights and darks, picking out details of the patchwork quilt on his bed. The strongest modeling is in the head, surrounded by hints of detail in the fabrics. The rest of the picture was painted with a few broad washes.*

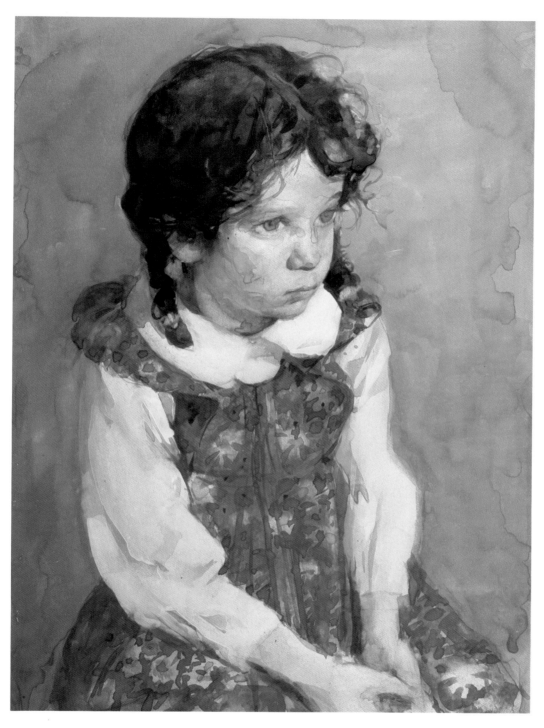

Karen, *1981, watercolor on plate bristol, 15″ x 10″ (38 x 25 cm), collection of the artist. I started this painting a year earlier, in Italy, when my daughter earnestly promised that she "would* really *pose this time." Of course, I knew this wasn't going to happen—not with a five-year-old model. I knew that I'd have to photograph her in order to finish the painting later on. Working with the hard Italian water, I wasn't able to wipe out as freely as I normally do with the mineral water I use in my New York studio. I finally had to add some opaque white to the mixtures on the blouse to get rid of some random staining and poor modeling. But I think this worked out reasonably well because I used the semi-opaque mixture as a flat* color—*not merely to lighten a value.*

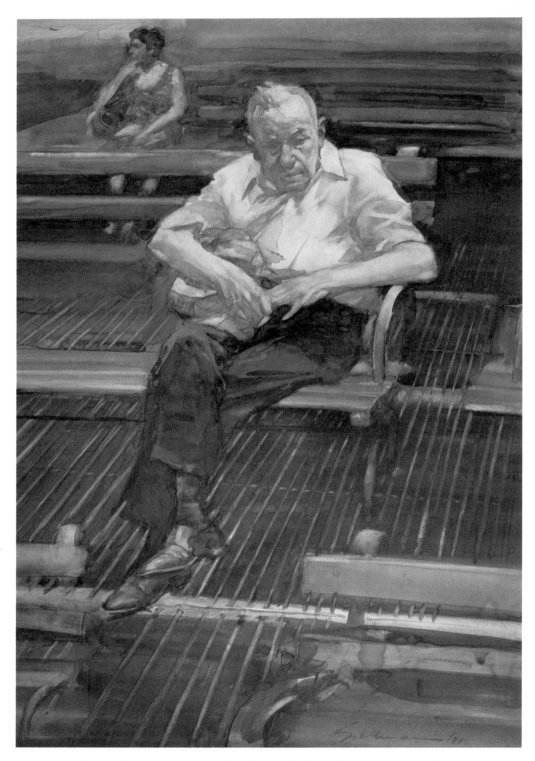

The Bench Sitter, 1981, watercolor on plate bristol, 22″ x 15″ (56 x 38 cm), collection of the artist. Seated figures can become boring if they have no special emotional convent. That's why I was particularly interested in such pictorial devices as the benches, the subway grating, and the grim darks, all of which were intended to suggest some sociological or psychological content. Compositionally, these elements were also meant to minimize the inherent deficits of the pose. In a broad sense, all the paintings in this chapter face the same challenge.

The Toolmaker

For the past ten years, our family has spent the summers in a small town in northern Italy called Pietrasanta. Few American tourists know the town, though in recent years it's become somewhat better known. It's in the center of the Italian marble cutting and finishing region capped by Carrara, a mere fifteen miles to the north. Pietrasanta is popular with sculptors and therefore I enjoy the place all the more. Being the only painter in town is both a distinction and a respite from the competitive wars of New York.

A sculptor friend, who's spent many years in Pietrasanta and gotten to know many of the artisans, told me of a wonderful craftsman whom I might enjoy painting: a huge, bearlike, gentle man who works in a tiny shack, making fine chisels for the marble cutters of the region. I was eager to meet the toolmaker because, each summer, I've sought out and painted a number of the marble cutters: white-hatted, chalk-covered artisans who serve sculptors around the world, carving huge Henry Moore pieces and also making gorgeous copies of dreadful nineteenth-century madonnas for wealthy clients.

Taking some drawing materials with me, I drove over to the toolmaker's workshop. He'd been told of my interest in drawing him and he was quite agreeable to the idea. But I wasn't prepared for his workplace. Just off an isolated side road, the structure was like a small woodshed with a single, tiny window to provide ventilation. The interior was virtually black because the walls were encrusted with soot from the charcoal fire that glowed on a small metal bench at more than six feet square.

As soon as I entered, I felt the handgrasp of a smiling and affable craftsman. It took several minutes to adjust my eyes to the darkness and to sort out what I was going to do. I'd imagined a very different setting for this painting, something closer to the firelit interior of a typical Tuscan farmhouse. In a sense, I'd already painted the picture in my head before I got there, only to have it erased by this dismal setting.

But my charming sitter took me out of this mild state of disappointment by his interest in my work and his willingness to talk about many things, including his lifelong struggle against injustice. Like so many Italian working people, he considered himself a communist, but the kind that many communist party officials abhorred because he was an idealist as well. He was a natural foe of the party bureaucracy.

He sat on a small concrete form close to the doorway. By chance, the door swung open, allowing the morning sunlight to streak in at his feet, sending up a glow of light that bounced off his glasses, partly obscuring his eyes. I knew at once how I wanted to paint him. The only trouble was that it was impossible to work in this place—even with my convenient watercolors. I made a couple of drawings of him and arranged for him to come to sit for me at the studio, back at my house.

For a few days, I thought about how I could set up an environment that simulated the setting back at the shed. I decided to work with artificial light, placing one light on the floor near his feet, and using another to provide enough light to work on the painting. By closing the shutters of my studio—which wasn't really a lot bigger than his shed—I could recreate the dim interior in which the toolmaker worked. My only fear was that the light in the studio wouldn't work as well as the natural light, and I might have to abandon the idea or do something less interesting in the painting.

Before my sitter arrived, I spent the next hour or two fussing with small thumbnail sketches of alternative poses. But nothing seemed right. I felt that I needed that environment back at the shed, or possibly his own house, which seemed a far better solution, even though I didn't know what it looked like or whether I'd be surrounded by a squadron of lovely family members, all hanging about, asking questions, and causing my head to spin.

I decided to dive in and take my chances in my own studio. The result is the demonstration that you see here.

Marble Cutter, 1974, watercolor on clay-coated paper, 15½″ x 9½″ (38 x 24 cm), collection of the artist. Although this was one of my more successful paintings on that clay-coated paper, I'm bothered by the fact I don't immediately get the feeling that it's a watercolor. One of the peculiarities of clay-coated paper is that the painting surface often retains the imprint of the brush hairs, as you can see in the lower half of the picture. In some ways, this is attractive and gives a feeling of solidity to the painting, but it's also one of the reasons that led me to abandon the clay-coated paper. I enjoy the wet, flowing look of the color, and that's what I could never seem to get on the paper that I used for this picture.

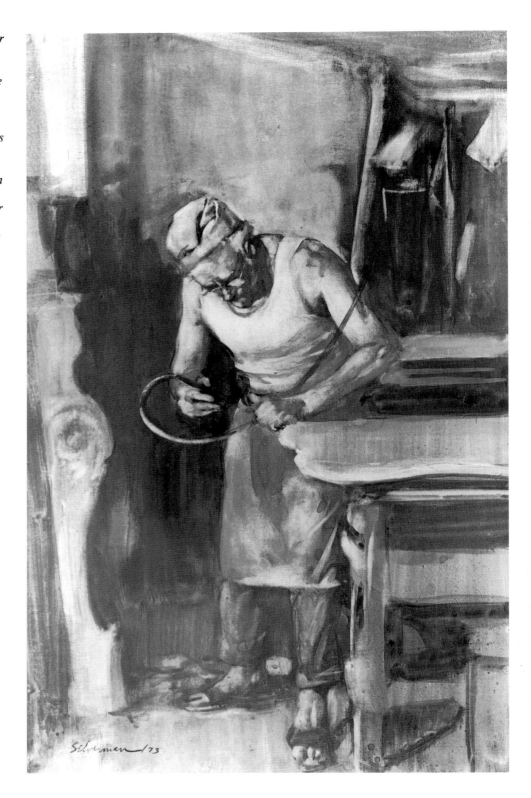

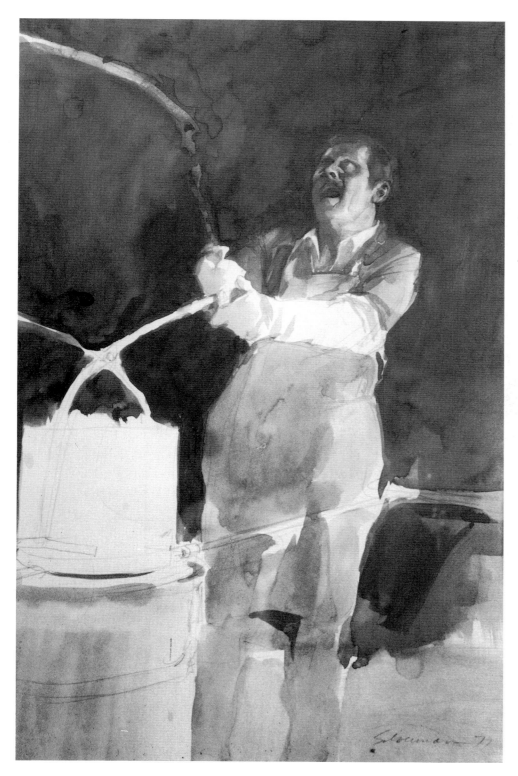

Pouring the Bronze, *1977, watercolor on hot-pressed watercolor paper, 20″ x 15″ (51 x 38 cm), collection of the artist. With increasing confidence in my new understanding of watercolor, I made this study of a foundry worker in Pietrasanta, about to turn a cauldron of molten bronze. In contrast with* Marble Cutter, *this painting has a directness, fluidity, and spontaneity that satisfy me more fully. On the other hand, I suspect that the painting betrays too much of the photograph from which I worked.*

The Toolmaker, I *1980, charcoal and carbon pencil on gray paper, 16" x 12" (40 x 30 cm), collection of the artist. This is the first pose that the toolmaker took in his small, cell-like work-place. The soft vine charcoal enabled me to work quickly, setting up the image and the atmosphere of the small, dark room. I used a stomp to blend the initial modeling. Then I worked over that with a carbon pencil, articulating the features more precisely. Back in my studio, I added the white accents with chalk.*

The Toolmaker II, *1980, charcoal and carbon pencil, 14" x 11" (36 x 28 cm), collection of the artist. Anticipating the possibility that I might not be able to paint the man in his workshop, I made this second study as an alternate idea for the painting. I worked even more rapidly. I later chose this seated position as the one to paint because it seemed more closely related to the character of the model.*

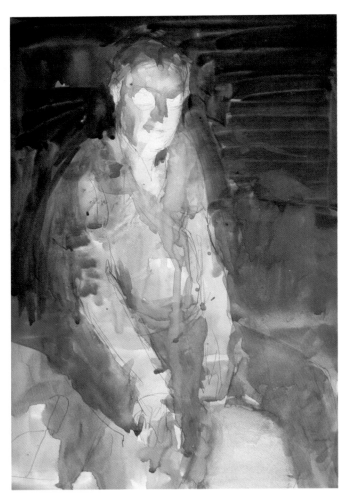

Stage 1: Just after lunch—but a couple of hours before I expect my model to arrive—I lay in the first washes of color, which are based on the very quick sketch I made a few days ago. A deep gray wash covers most of the sheet. Then I load my brush with raw sienna and white, filling in a shape that approximates the form of the figure seated on the bench. Allowing some time for the color to set, I then add more dark umber to the background, especially in the lower left.

Stage 2: The toolmaker arrives a couple of hours after I start the painting. He's curious to see everything in the studio. I try to be polite, but I'm impatient to continue. I want to set up the lights and see if I really *can* continue. With some anxious moments—while my friendly model provided grunts of encouragement—I work out the lighting arrangements. To my delight, the figure emerges as I remember it in the shack. I try to recall the darks on his face and body; in his shed, they were darker and more dramatic than they are in my studio. I'm moving along at full tilt now, painting with loose, wet strokes. I add lots of Payne's gray to the background. I brush in the warm values that will form the dark side of his head and features. Then I add some cool notes to the slowly drying, but still runny patches of warm color on the head. Unfortunately, he's wearing a dark green sportshirt, but I'll change it to olive.

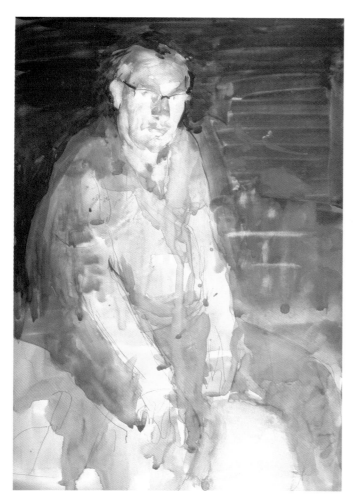

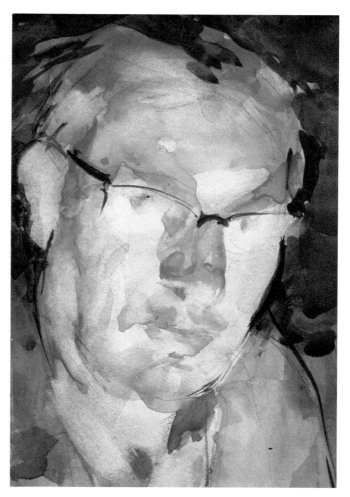

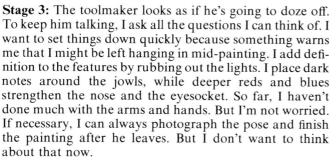

Stage 3: The toolmaker looks as if he's going to doze off. To keep him talking, I ask all the questions I can think of. I want to set things down quickly because something warns me that I might be left hanging in mid-painting. I add definition to the features by rubbing out the lights. I place dark notes around the jowls, while deeper reds and blues strengthen the nose and the eyesocket. So far, I haven't done much with the arms and hands. But I'm not worried. If necessary, I can always photograph the pose and finish the painting after he leaves. But I don't want to think about that now.

Stage 3 (detail): In this closeup, you can see how I add definition to the eyes and rub away some color to suggest the light striking the glasses. A few dark lines suggest the frames of the glasses, and I add some dark strokes to define the outer edges of the head more precisely. I already have a pretty good idea of the pattern of light and shadow on the head. I must stop, take stock, and let the painting dry thoroughly, so the paint will hold better when I start painting again.

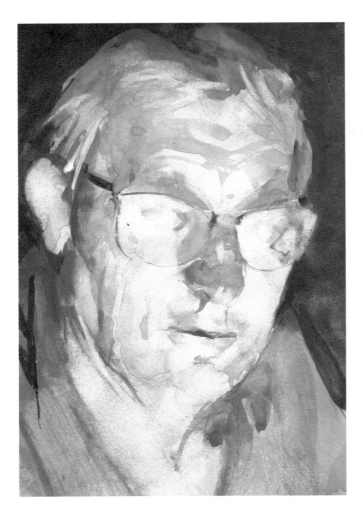

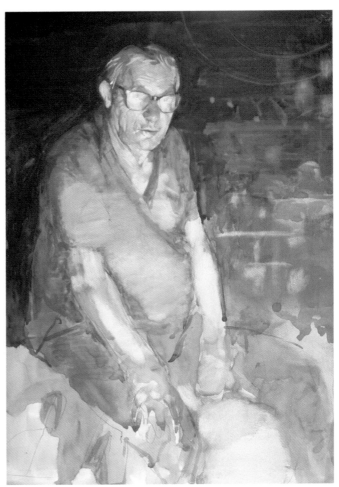

Stage 4 (detail): I offer my guest some wine, risking a change in his mood. He may become too jolly or too serious. But he's a man who understands a fellow craftsman, and his manner is unchanged. I work on the background, picking out random lines to suggest the scratches on the wall of his workshop, adding blots and patches to form a kind of abstraction. I wipe out some more light from the head and then brush in more detail. The eyes are wiped to suggest the glare on his glasses. Now the lights on the face are more subtle. Some more wiping unifies the tone of his shirt. I change his facial expression so that it looks less tentative, more sturdy and curious. That's better.

Stage 5: The painting is moving along well, even as my model is tiring. I feel the exhilarating sense of urgency that often comes when I'm working directly from life, knowing that the model has to leave soon. I quickly brush some more color on the arms and hands, wiping away the lights from the warm tone. Then I add more Davy's gray to the trousers. Now back to the head.

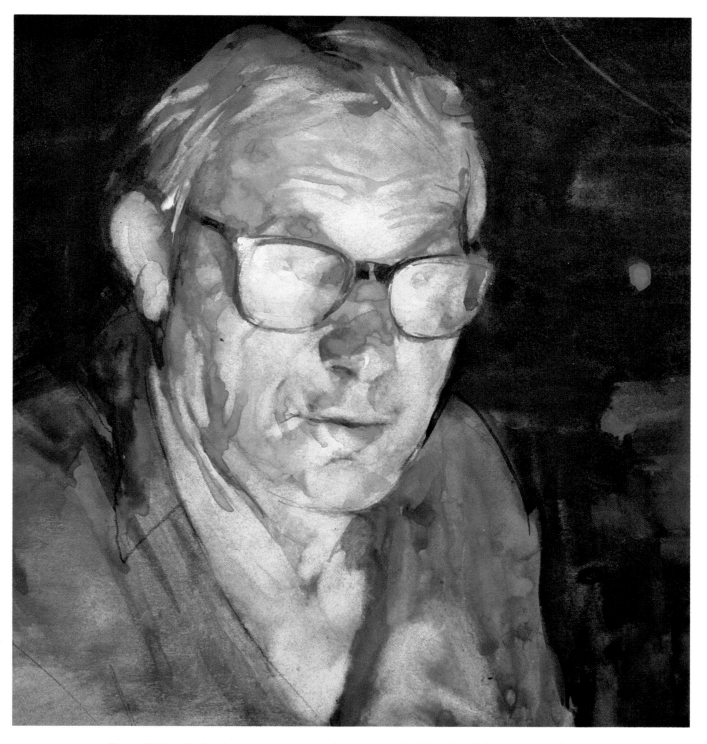

Stage 5 (detail): I rub out some more color around the left side of the nose and down toward the mouth. Then I add darker values to the forms behind the glasses, floating some more ochres and pinks into the shadow area on top of the nose. Now the forms seem more solid, although I think I'm going to need some transitional tones to make it all hang together. Notice how I lift some streaks of light from the hair, using the tip of a brush. I also use a small brush to draw the eyeglasses more exactly. At this stage, I'm also paying more attention to details like the line of the mouth and nostril, the highlight on the tip of the nose, and the wrinkles.

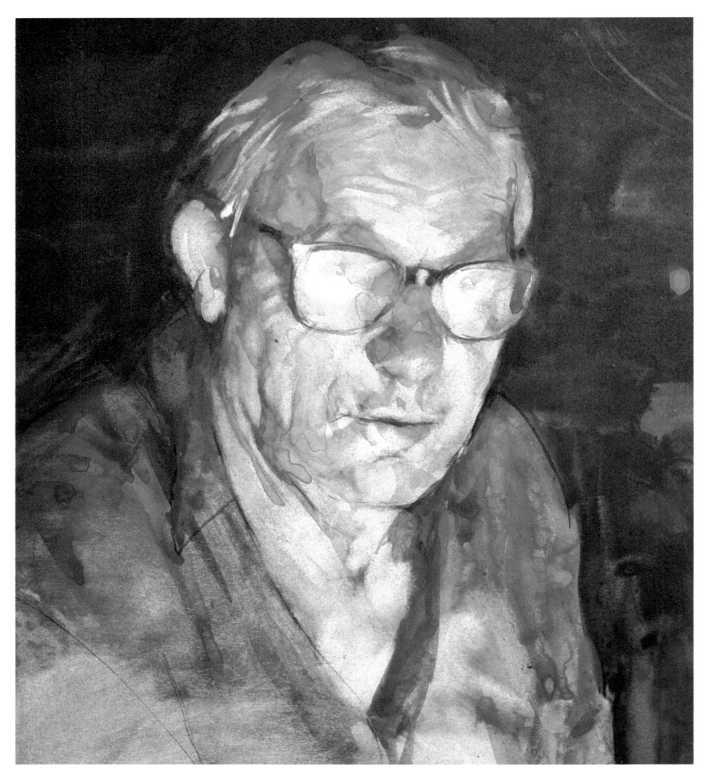

Stage 6 (detail): I'm getting close to the end now. I think my guest has been making signals that he must leave. And fatigue is beginning to set in with me too. I keep adding and taking things out of the head. I shape the nose so that it looks a bit thicker, and the nostril is less distinct again. I also like the elusiveness of the eye as it blurs out behind the glasses. The hair still doesn't seem right. But I can adjust this later.

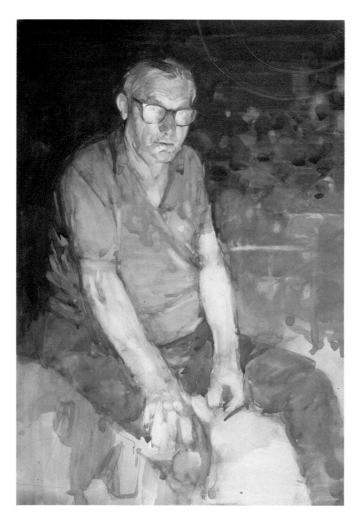

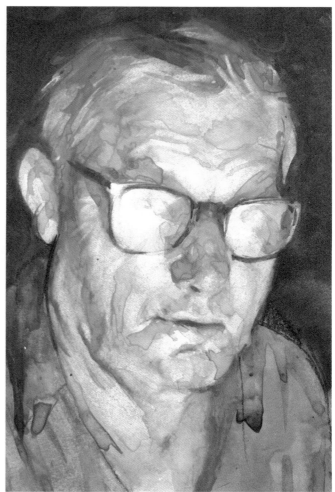

Stage 7: I go on to amplify the arm with a broad run of warm color. I rub out the lights as soon as the color dries. The hands need some work, and I start to rub out the lights on the fingers and knuckles. I give the shirt a cool wash to bring it closer to the cool tones in the wall. But then I regret this immediately. I'll have to attend to such things after the model leaves.

Stage 7 (detail): Now there are more cool notes in the face—little, grayish puddles around the eyes, mouth, and chin. I also do some more work on the hair, painting out some of those obvious streaks of light that have been troubling me. The dark line of the mouth is softer now.

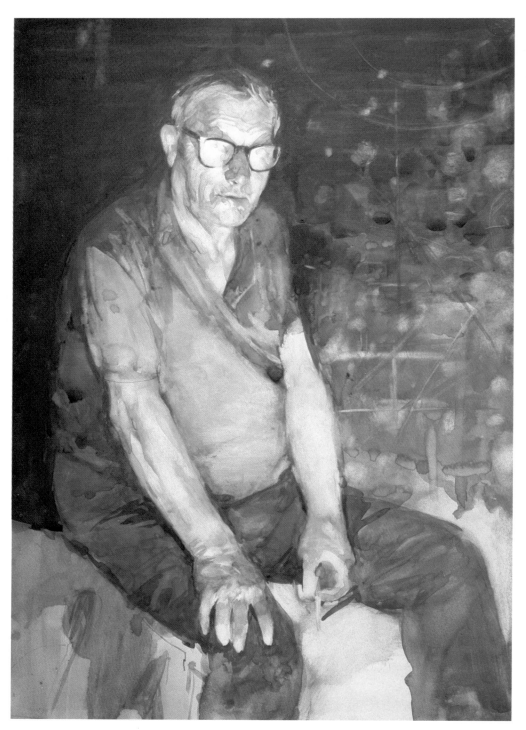

Stage 8: My guest is leaving. He's fascinated by the painting and promises to return the following week. I thank him in my most polished Italian, which is a bit ragged by the end of the day. I insist on taking a picture of him just in case. Thinking, as Italians do, that tomorrow is forever, I assume that he'll get back somehow. But this never happens. Luckily, I have that photograph. So I've got a record of the lights and shadows on the shirt, which I solidify with dark washes along his shoulders and back. I also finish up the arms and hands, doing more modeling on the forearm and hand that's closest to the foreground, and keeping the more distant arm and hand a simple, pale silhouette. The shapes of the hands become stronger as I surround them with the dark folds and shadows on the trousers. Now you can see the interesting pattern of lines and little rubouts on the soot-covered background wall.

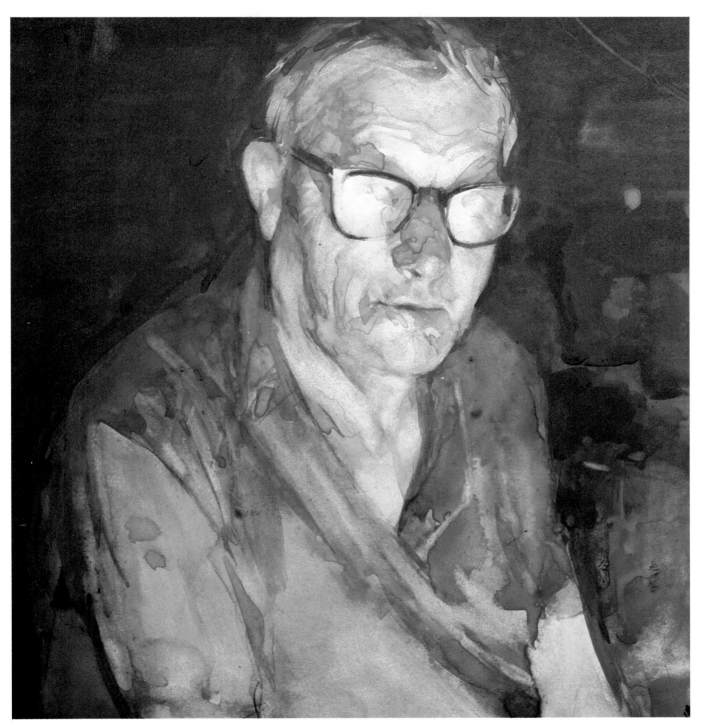

Stage 8 (detail): The finished head and shoulders have all those accidental little drips and pools of color that are so typical of a watercolor painted on smooth paper. They all add to the feeling of flickering, unpredictable light in the toolmaker's small, shadowy workshop. The dark tone on his shoulders melts away into the shadowy background, allowing his head to move forward more dramatically into the magical light that breaks through the open doorway. Despite the unfinished segments, I'm satisfied that the painting has a kind of integrity. Sometimes that's more than enough. *The Toolmaker*, painted in 1981, measures 22″ x 14″ (56 x 36 cm) and is done on plate bristol paper, as usual.

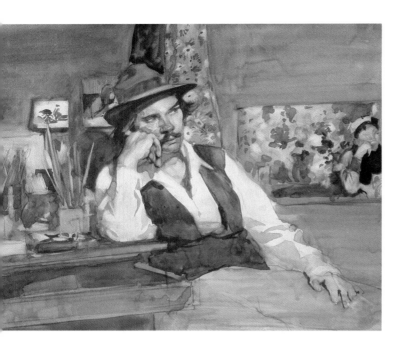

In the Studio, *1978, watercolor on plate bristol, 14″ x 20″ (36 x 51 cm), private collection. This painting was a kind of private game. It wasn't so much a study of a particular model as a dialogue between myself and art history. Inadvertently, the model took a pose that mirrored the Degas painting,* Woman with Chrysanthemums, *a reproduction of which was pinned on the wall behind him. I found this accident both amusing and intriguing, and I enjoyed the idea of playing a visual game, exploiting the differences in style and content between my painting and the Degas. The slightly angry look in the man's face, which was really unintentional, somehow adds another dimension to that dialogue.*

Tinted Glasses, *1975, watercolor on plate bristol, 14″ x 10″ (36 x 25 cm), collection of the artist. This is an early example of my efforts on plate bristol paper, where I didn't take full advantage of its technical possibilities. However, the picture deals more successfully with this model than I felt was possible at the time I painted it. Hiding behind his tinted glasses, the young man seemed totally inaccessible, defending himself with a kind of neutrality that seemed to defy even the most skillful observer. I made this blandness the point of the picture.*

(right) ***A Black Man,*** *1977, watercolor on plate bristol, 21½″ x 13″ (55 x 33 cm), collection of the artist. I emphasized the whiteness of the model's shirt and pants to create a dramatic contrast with the questioning, apprehensive look in his dark face. The graphic shapes of his legs, arms, and body all focus attention on the head. I had some difficulty with the paper because I failed to wipe away the color soon enough. I couldn't remove that small ochre stain on the left arm. But the clothing still has a strong graphic shape, and it's pale enough to emphasize the mood of the sitter's face.*

Looking Toward the Sea

While passing street painters in Paris along the banks of the Seine, Picasso is reported to have said that he expected to see bad art every time he saw a painting being done on-the-spot. Although there *is* a great deal of evidence to support this antipathy to outdoor painting, Picasso also ignored the formidable amount of great painting that *was* done on location during the past two centuries. I think he might have liked what he saw if he'd taken a walk along the Seine or the Thames a century earlier.

But I think the thrust of his remark is right: merely copying nature is insufficient. Art that's based on observation must also involve some kind of transformation of nature, some special vision. Just reproducing some conventionally beautiful subject will lead to banal and repetitive painting. No amount of skill or technical bravura can save a fundamentally ordinary vision from this kind of mediocrity.

However, if I've been wary of conventional beauty in subject matter, I've also been guilty of something else. My older work has shown *too much* point-of-view—but one that's not totally my own. In the past, I'm afraid that I've approached landscape with too much Constable, Turner, or Bonington getting in the way. Thus, while many of my landscapes seemed successful, I feel that they were a bit too derivative. For this reason, among others, I more or less stopped painting landscapes for almost ten years. I think the break served to clear my head and my eye. When I went outdoors with my paintbox again in 1978 and

(left) **Picnic,** *1978, watercolor on plate illustration board, 21″ x 15″ (53 x 38 cm), collection of the artist. As I do in many of my landscapes, I tried to introduce some evidence of contemporary life in a scene that would otherwise be timeless. The umbrella pines depicted here have been around for a long time; the plastic and aluminum folding chairs have not, nor will they be. I was tempted to paint the big tree on the left with an enormous amount of detail because it was a marvelous thing to paint. But I felt that all this detail would overwhelm the image.*

1980, I felt that I was more my own man. I even felt that my old-fashioned romanticism was very much *me*: I still react most strongly to the sunset hour! And I still have more affection for the valiant old, as opposed to the freshly new.

About five years ago, I proposed that I paint a picture story for *Esquire* on Pietrasanta. I'd become very attached to the place for all sorts of reasons—including the fact that I could work there almost uninterrupted, doing what seemed like days of work in just one morning. There were people everywhere, ready to pose, and *no telephone*.

That summer, as I set about painting things that would give a true sense of the special beauty of Pietrasanta, I realized that a few landscapes would be a necessity. Each morning, I woke to the sight of the town, stretching out below us, the view partially cut off by a row of trees that were rich green, their tops raked by the angular rays of the morning sun. The view was graphic and affecting. Of course, the special light lasted only a few hours, at best. But I felt confident about painting it in watercolor. The inherent speed of the medium and the quick-drying color would enable me to capture the significant aspects of the image before the light changed everything.

I must admit that I was a bit unsure of my ability to function—let alone paint—at 8:00 A.M. Being a child of the city, where it's gray in the morning and where the sun can be hidden for long months, I found it a shock to wake to the brilliant light and sharp edges of the Mediterranean landscape. On the other hand, it was this very clarity and freshness that attracted me to the view in the first place. And the ease of getting to the scene, right outside my door, made the whole project seem even more appealing.

Although this book is mainly about painting people in watercolor, I thought it might be helpful to show how this method works when painting a landscape. I also should mention that the picture in this demonstration wasn't painted five years ago, at the time of *Esquire* project, but in 1980.

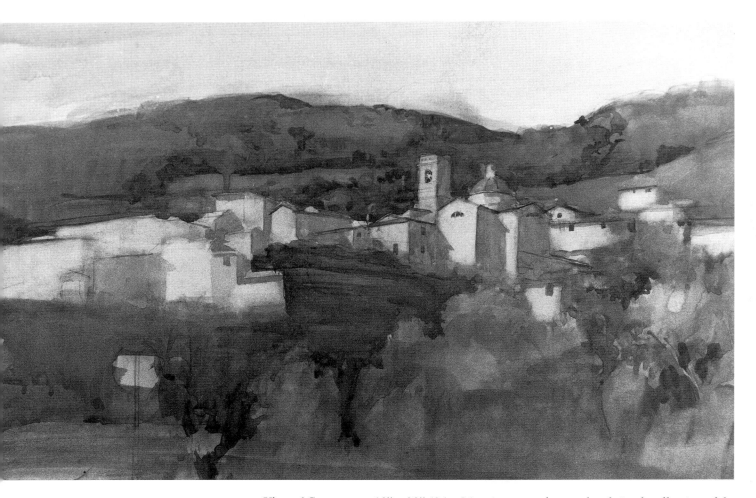

View of Cappezano, 13″ x 22″ (34 x 56 cm), watercolor on plate bristol, collection of the artist. This is an unfinished version of the painting that's reproduced in color after the landscape demonstration that you'll see later in the book. After three hours of work, perched on the side of a small dirt road high above the town of Pietrasanta, I simply decided to quit. Fatigue, the eternal buzzing and biting of the flies, the shifting sun that crept into my shaded spot and seemed to bleach the colors—all this made me long for the cool shelter of my studio. Even at this unfinished stage, I thought the picture looked good and I could almost have stopped there. but I took a photograph of the scene so that I could finish some unresolved details of the buildings on the far left. The completed painting is reproduced in color on page 123.

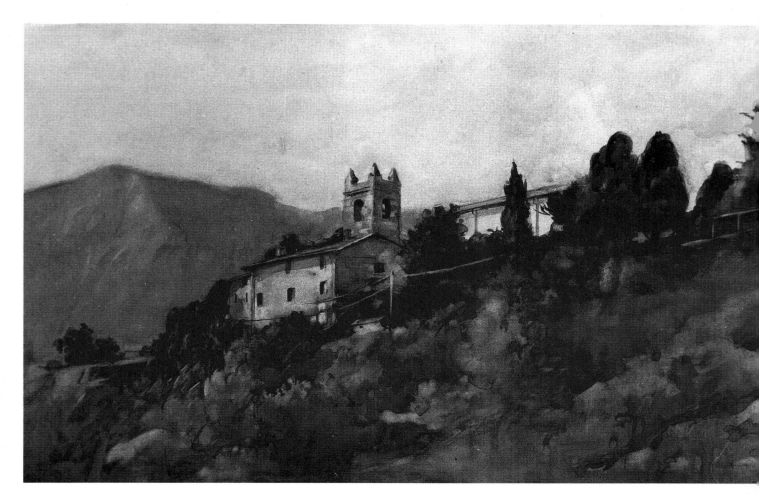

In the Mountains, *1980, watercolor on plate bristol, 13″ x 23″ (33 x 58 cm), collection of the artist. Perhaps this is an overstated and romantic view for contemporary taste, but it's nevertheless true to the spirit of the place. This hilltop still feels like an outpost—a refuge from the stress of urban life that exists below in the rest of Italy. In fact, the place is unchanged from the days when it was actually a refuge from the sixteenth century bandits who roamed the Tuscan countryside. I did most of the picture on location, wiping the sky to emphasize the light, and building up the vegetation with loose, irregular brushwork. I exploited the drips and blots to suggest the texture and detail of the foliage on the hillside. Back in the studio, I made a few small corrections from a photo.*

(above) **Art Deco,** *1980, watercolor on plate bristol, 10″ x 14″ (25 x 36 cm), collection of the artist. This picture was generated by something like the feeling behind* House and Palm Tree. *This time, however, I think the painting came off. I was interested in getting at the contrast between the dark, jagged, slightly threatening feeling of the tropical foliage and the passive elegance of the architecture. I did a lot of wiping and rubbing to recreate the soft, luminous afternoon light on the walls of this delicate and sad nineteenth-century survivor.*

(left) **House and Palm Tree,** *1978, watercolor on plate illustration board, 20″ x 14″ (51 x 36 cm), collection of the artist. Almost every day during my summer vacations in Pietrasanta, I used to notice this house and the lone palm tree silhouetted against the waterstained facade. When I finally decided to paint it, my feeling of involvement—that original fascination—seemed to evaporate. That's why some portions of the painting are left unfinished, suggesting my ambivalence about the picture. On the other hand, perhaps there's a kind of eerie fascination about the dark shape of the pine against the pale, almost ghostly architectural forms.*

Stage 1: I gather all my equipment and set it up the night before, so I can start painting immediately in the morning. Just after daybreak, I start to paint with a feeling of great clarity and enthusiasm. (There really *is* something special about starting work with the first light.) The masses in the foreground are laid in with broad, wet washes of blue, green, and umber tints. I put down a whitish-blue ground for the distant objects. As in all my pictures, this operation takes just a few minutes.

Stage 2: It's twenty minutes later. The damp morning air slows drying. I pick out the salient shapes of the darks, which will define the palm trees and the band of sunlight that catches the tops of the trees. I add more washes of bluish-white for the distant morning haze. So far, the whole picture consists mainly of drips and streaks, though you can see a few suggestions of the palm trees.

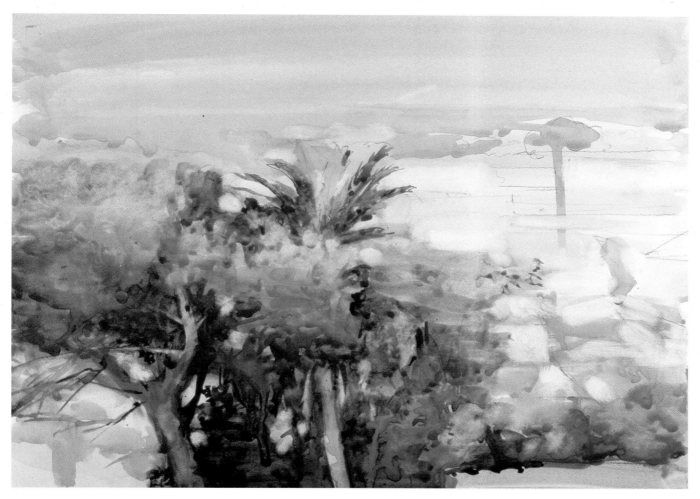

Stage 3: The sun is moving swiftly now and I must work fast to establish the patterns and colors. I work very rapidly on the dark masses of the trees in the foreground, letting the color drip and puddle to suggest the complex foliage and the patterns of light and shadow. I wipe out a few of the lights seen through the trees and along the tops of the foliage. Right now, I think the whole thing looks too patchy and fragmented. I must keep in mind that mass of rich greens, browns, and purples, with all the small details of twisted branches, the tops of palm leaves, and the flecks of sunlight, all topped with light and unified by a wonderful, sweeping shape. Here again, watercolor is so well-suited to this task. The speed and flexibility of watercolor allows me to generalize in some areas and be specific in others, almost without pausing.

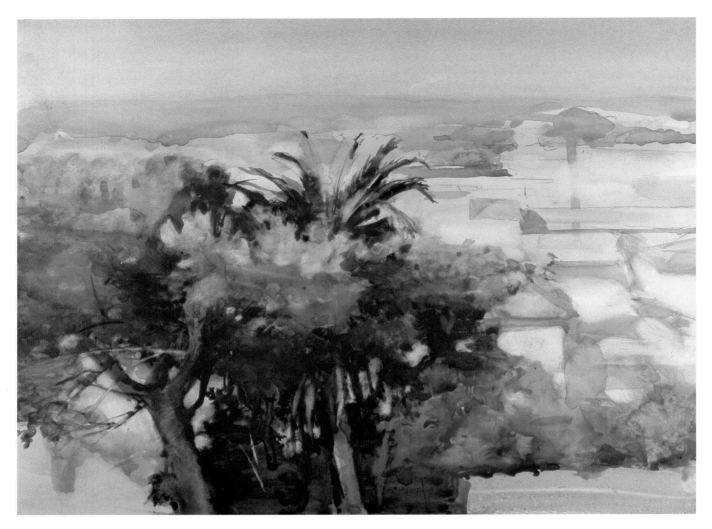

Stage 4: I'm building up the darks of the foreground trees and strengthening the sense of detail. These darks are additional layers of deep umber and green washes. I'm still keeping the basic contours of the shapes as I established them early in the picture. I do some wiping in the sky to smooth out the tone, and then I add the cool color of the horizon shape. Little warm patches suggest the tile roofs of the town below. Beneath the roofs, I wipe out some shapes to create the walls of the houses in the sunlight. Bands of blue shadow appear under the roof lines.

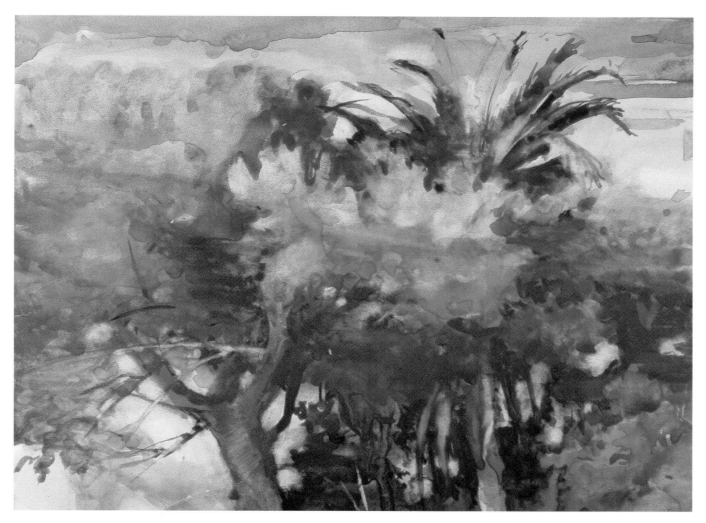

Stage 4 (detail): Here's a closeup of the trees, showing how I reinforce the darks and wipe away those small patches of light where the sun breaks through between the trunks and branches. I'm very selective about picking out details like the branches at the top and the few branches within the shadows. The rest of the brushwork is loose, washy, and full of those controlled accidents that make watercolor so enjoyable.

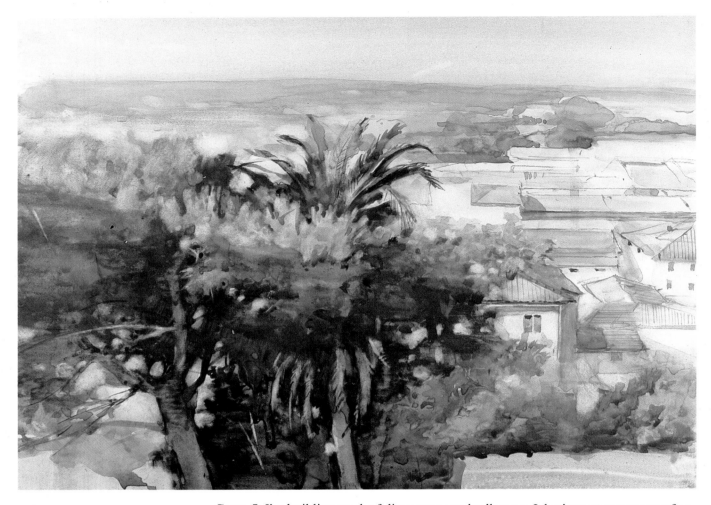

Stage 5: I'm building up the foliage very gradually now, I don't want *too* many refinements. At the right, I'm working on the houses, wiping out more lights, rendering the details of the rooftops, putting in windows, and defining the shadows more exactly. I have to hurry now. It's almost 10:00 A.M., and I can really feel the changes in the angle of the sun.

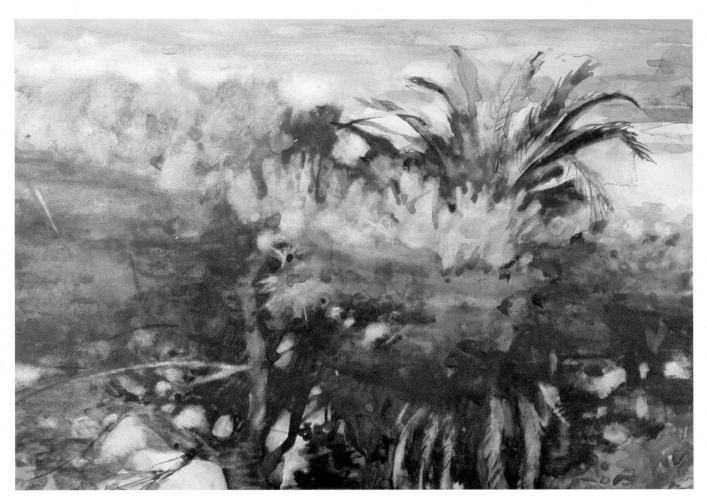

Stage 5 (detail): A closeup of the trees in this next-to-last stage shows how I add darks very selectively to unify the sweeping, shadowy mass, without adding too much complexity. I'm also careful about adding just enough detail to the branches without fragmenting the big, dark shape. In fact, I think the whole area hangs together now and looks less fragmented than it was earlier. You can still see lots of little rubs, like pale fingerprints, where I pick out the lights with a wet towel wrapped around my fingertip.

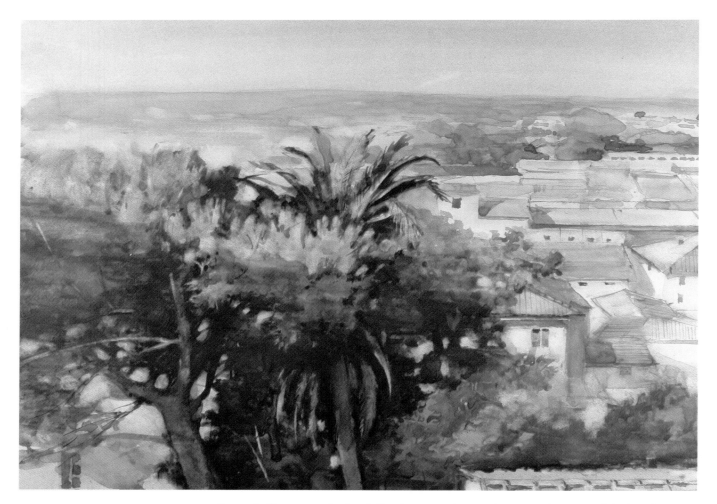

Stage 6: I'm up again the following morning at the same time to finish the picture. I add finishing touches of darkness and detail to the group of trees. I gently float a ribbon of gold ochre and sap green over the topmost area of the trees. I allow this to dry, and then I pick out some of the color to strengthen the feeling of sunlight on the foliage. I add a few more details to the houses at the right, including that tiled rooftop in the extreme lower right corner. All these linear strokes are made with the sharp point of a small Artsign brush. I also do a bit more work on that cool band of horizon just beneath the sky, suggesting a few more trees with small puddles of cool color, and also adding some warm touches to indicate more rooftops beyond the town. Now I'm more satisfied with the trees, which read as a single dark mass, sunlit at the top and punctuated with bits of light that come through from the distance. I like the painting, but, as always, I wonder whether I've done too much rendering, whether the painting would have benefited by being simpler, more concise, more abbreviated. I always seem to have second thoughts! *Looking Toward the Sea*, painted in 1980, is 10½" x 13" (27 x 33 cm) and done on plate bristol paper.

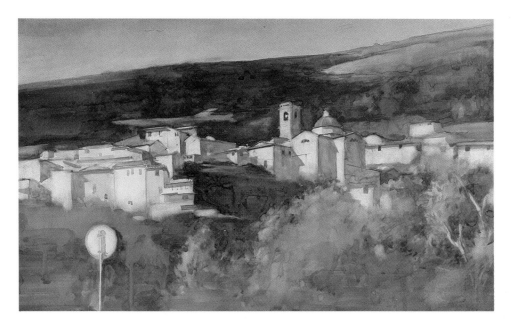

View of Cappezano, *1980, watercolor on plate bristol, 13" x 22" (34 x 56 cm), collection of the artist. This is the finished version of the painting that you saw earlier on page 112. When I got back to the studio, I strengthened the line of the hills behind the town and did some more work to define the shapes of the buildings. I also developed the trees in the foreground and added the roadsign in the lower left.*

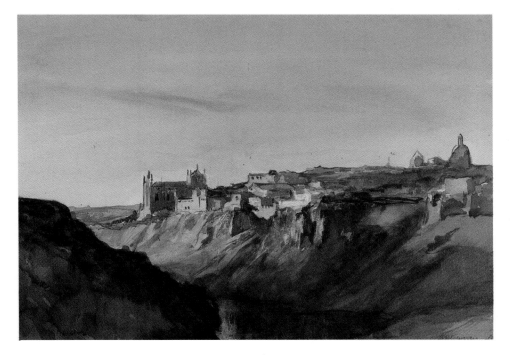

View of Toledo, *1964, watercolor on hot pressed watercolor paper, 14" x 18" (36 x 48 cm), collection of Lois and Harvey Dinnerstein. This is a far more successful picture than many that were done at the time when I was working on traditional watercolor papers. The picture may owe too much to Turner, or even to Corot, but it's clearly an expression of my romantic inclinations. I find it intriguing to compare this with* View of Cappezano, *done fifteen years later; although the same sensibilities underlie both paintings, the earlier one really looks like it was done in another era! When I painted the picture, I was curious to discover where El Greco might have stood when he painted his brooding and monumental* View of Toledo. *I realized afterward that his painting must have been done from fragments of memory, rather than from direct observation.*

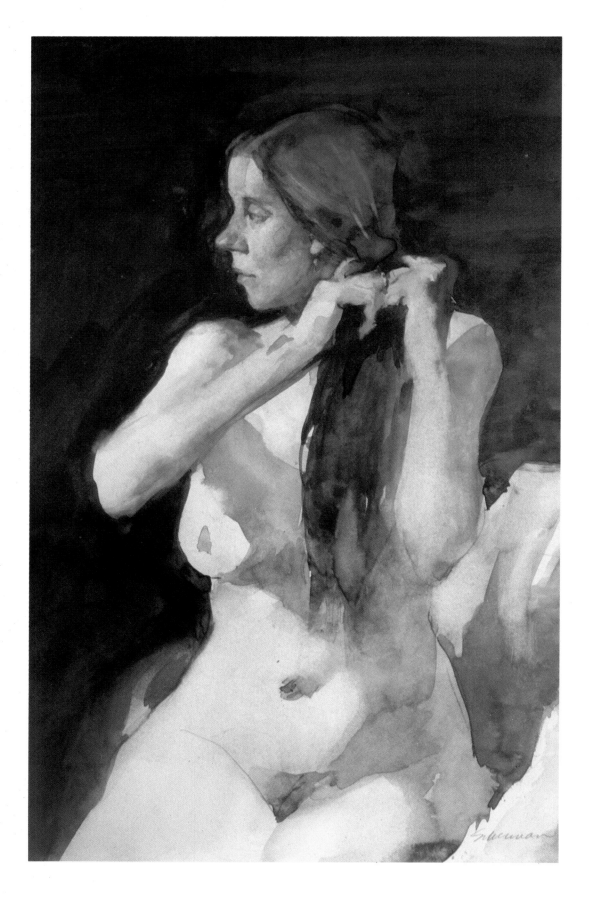

Nude

The nude figure has been a major subject for painting since the Renaissance. Throughout this long history, there's never been any challenge to the assumption that painting a female nude was a completely valid, even obligatory, part of the artist's repertoire. However, in recent years the feminist movement has challenged this assumption. At the same time, there's been less interest in painting the nude on the part of artists in general. In recent years, this too has changed. More artists, both male and female, seem to be interested in painting nudes—male and female.

My own feelings about the subject have been complicated. On the one hand, I'm sympathetic to the feminist viewpoint. On the other hand, I've always been interested in finding some way to paint a nude that looked natural, unstaged, and somehow related to contemporary life. Furthermore, I've generally lost interest in the conventional studio nude as a subject, and I've looked elsewhere to find situations where nudity—or at least some form of undraped figure—played a more interesting, and possibly more significant, role in contemporary life. This led me to

the fantasy world of the burlesque dancers and the topless go-go girls. Whatever success these paintings may have had—or not had—they were clearly more challenging than the conventional nude because they centered on a lot of contradictory emotions within myself and within society.

These burlesque paintings were done in the 1960s. By the mid-seventies, I'd shifted my attention to other situations, like the beach, where the human figure could be painted in the flesh without appearing forced or artificial. Despite this, I've sometimes returned to painting the nude, as if to touch base with a noble tradition. Occasionally, I turn to the nude specifically because I sense something unusual, even disturbing, in the person of the model—some unexpected quality that sparks my interest.

In this spirit, I was prompted to paint a nude that was based on a drawing I'd done several years ago in one of my classes. The drawing was a rather complete, detailed study. When I came across the study among many others in one of my portfolios, I felt that the figure suggested a strong idea for a painting. There was something in the pose and the facial expression that evoked a sense of tension, an arrested moment, that was different from other studio poses.

This feeling of "difference" also appeared in the dramatic light-and-dark patterns in the drawing, which seemed to translate immediately into a painting in my mind. I could almost *see* the painted image and the figure emerging from a misty, gray backround, tentatively poised at the edge of the bed. As things turned out, the light would, in fact, become the decisive element in the painting. And finally, I felt challenged by the idea of working from a drawing only, without any other reference.

(left) **Braiding Her Hair,** *1981, watercolor on plate bristol, 13″ x 9″ (34 x 23 cm) private collection. This was one of my rare returns to the conventional studio nude, but the active pose was chosen in hopes of avoiding that hackneyed feeling. Interestingly enough, the picture could just as easily have been painted from a clothed figure. I feel that it's an enjoyable picture because of the directness of observation and the simplicity of technique. The brushwork too is direct and the washes are broad and simple—the kind of thing that one might do on conventional papers—another reminder of the versatility of this paper, and of the fact that the techniques are limited only by the content of the picture.*

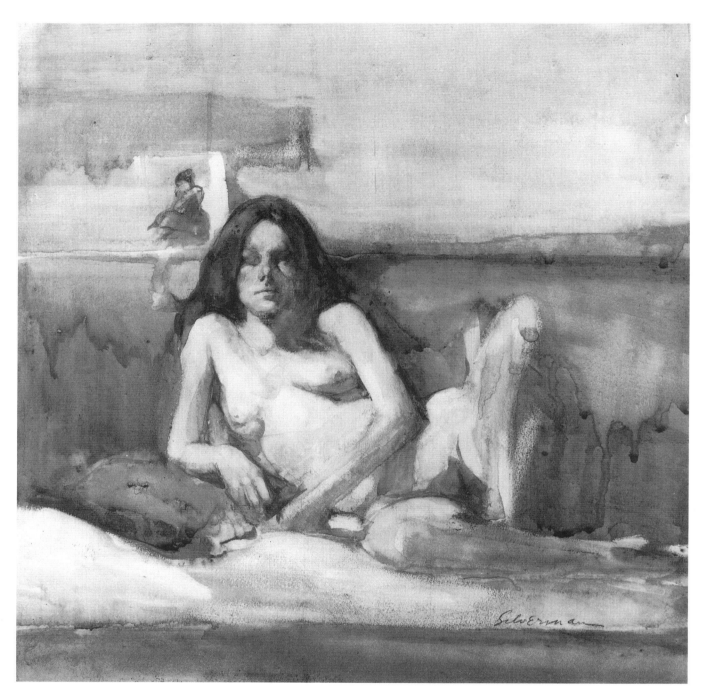

Reclining Nude, *1972, watercolor on gesso-coated rag board, 14⅜″ x 14″ (37 x 36 cm), collection of Robin and Carl Lubow, One of the few nudes I painted in the 1970s, this picture has some strong characteristics that I feel overcome the routine, repetitive qualities that I usually find in studio nudes. The fronval position helps. So does the lack of detail in the eyes, although I'm not sure I did this on purpose. There are some meaningless drips in the background and some unresolved passages in the body, but I think the handling of the paint has a kind of vitality and freshness. There's also something offbeat in the square format, with the curves and angles of the figure played off against the straight horizontal lines of the wall and floor. Ong curious footnote: someone bought the painting and then returned it because his wife thought it a dirty picture!*

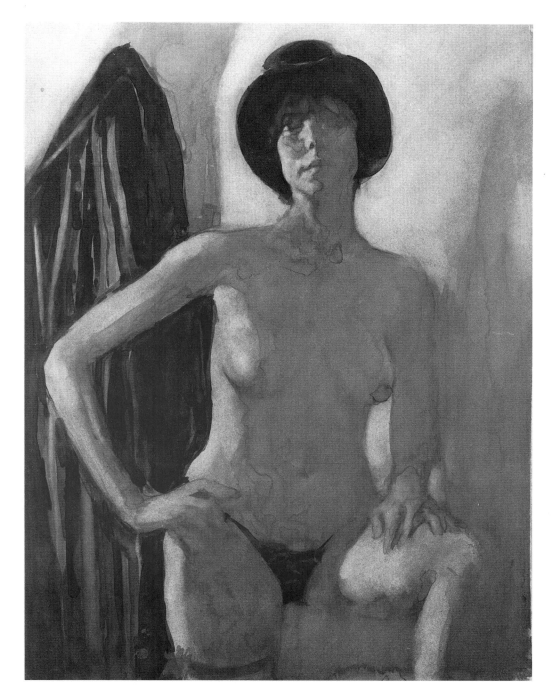

I'm a Dancer I, *1980, watercolor on plate bristol, 14" x 11" (33 x 28 cm), collection of the artist. This is a painting that I almost abandoned. Originally, it was just a tryout of the idea, hastily done, with much bad drawing. I kept going back to it, scrubbing, repainting, and adjusting until I finally resolved the painting into what I feel is a strong image of a young woman defending herself against a tacky theatrical role. The lighted edges of the figure were scrubbed out of the shadow. The silhouetted form was further dramatized by the dark hat, the patch of light behind the head, and the dark drapery that hangs on the wall.*

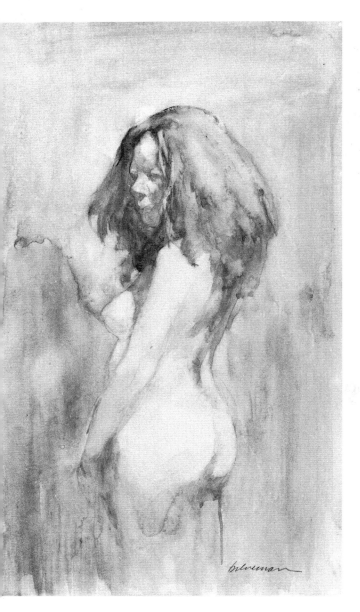

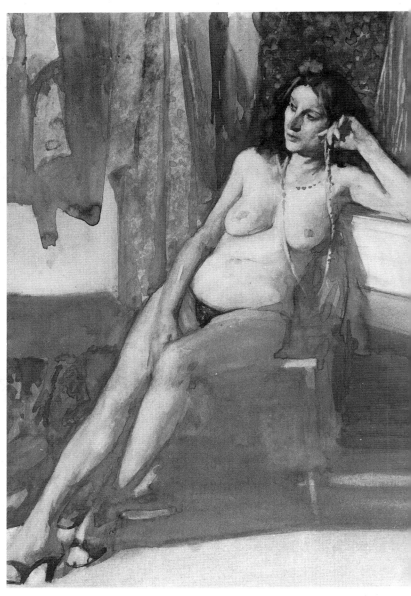

(left) **Red-Headed Nude,** *ca. 1968, watercolor on gesso-coated watercolor board, 12″ x 8″ (30 x 20 cm), private collection. When I painted this picture, I must have found this young woman a caricature of the stereotyped, classical nude. So I emphasized the comic, caricature element by playing up her large head and the more infantile proportions of her torso. Appropriately, her facial expression seems more confused than noble. You can see that I was still fighting the unpredictable gesso surface, which fortunately turns out to produce a washy, spontaneous look in this picture.*

(right) **Backstage,** *1980, watercolor on plate bristol, 14″ x 9″ (35 x 23 cm) collection of Mr. Milton Gelman. Here's another in a series of paintings of performers in which I attempted to explore the complex and contradictory aspects of their profession. The painting depicts a faintly tacky, rundown setting that contradicts the obvious sensuality of the nude figure. This point-of-view determined both the pose and the way the paint was handled: the thorough modeling of the figure; the patterns of the fabrics; and the highly simplified shadows in the foreground and the upper left.*

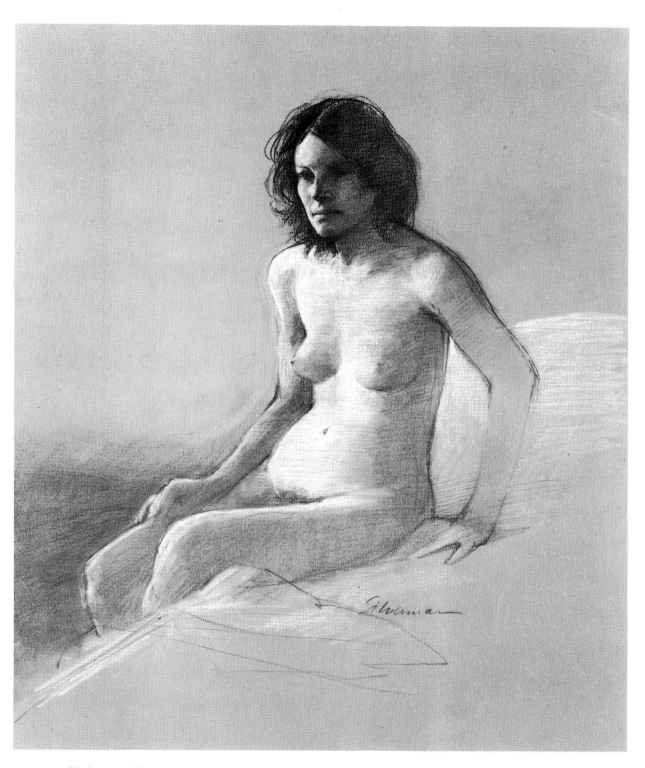

Nude, *ca. 1977, charcoal and white chalk on gray paper, 13" x 10" (33 x 25 cm), collection of the artist. The white chalk in this drawing made it possible for me to make the demonstration painting from the drawing alone. The strong suggestion of light striking the figure seemed to translate directly into a watercolor. And the combination of black and white in the drawing gave me a great deal of information about the face and bodily structure.*

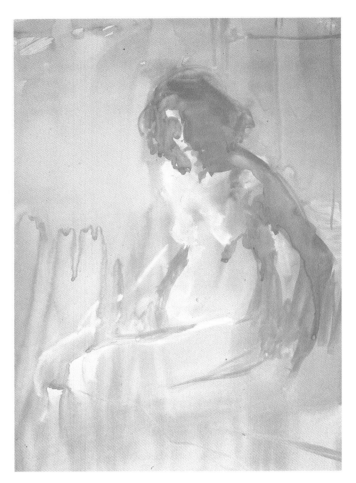

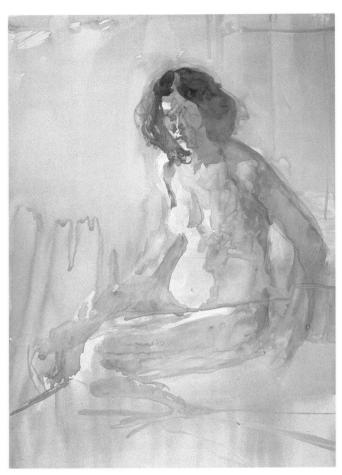

Stage 1: I like the idea of working only from the drawing, so I tack it up and set to work. I start out by applying a wash of golden ochre, with plenty of opaque white and water. Then I float a pale wash of ultramarine blue along the right side of the torso. While the paint is still wet and slightly runny, I towel out the lightstruck areas of the figure. Impulsively, I decide to change the posture of the torso somewhat by painting less of the left shoulder, so the figure is seen from more of a three-quarter view.

Stage 2: I add more subdued washes of ochre and pink to the head and torso. Very lightly, I brush some Payne's gray into the hair. The value change on the dark side of the figure, between the head and the hair, must be very slight. I run some more cool colors down the side of the torso. Throughout the figure, I'm building up the values very gradually, not committing myself to precise shapes just yet. I'm using more white in the colors than usual because I want a very fragile contrast between the figure and the background, as if she's in a room with a single window on a winter afternoon. Except for the initial wiping, I'm working on the picture without lifting out any color.

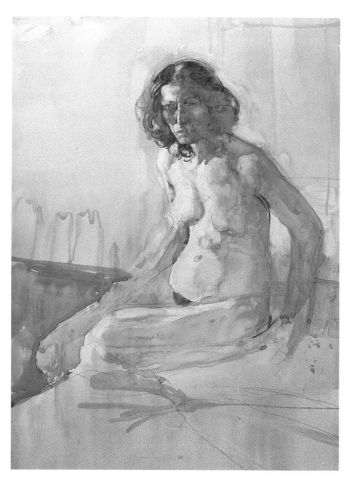

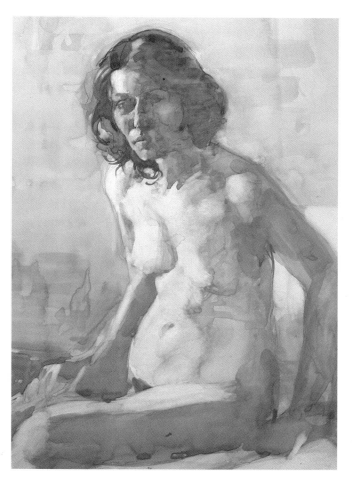

Stage 3: Another twenty minutes have passed. I add burnt sienna and cadmium red to the lower left corner. This is the darkest value in the painting, and I want to establish this darkest note so that I can relate the rest of the values to it. I add washes of raw sienna and some pinks to the right side of the head. A touch of umber in the hair keeps pace with this darkening of the face. I'm also adding darks to the rest of the body. I puddle some pale pinks on the light-struck areas of the torso. I know that I'm going to rub these down so the tone will be cooler.

Stage 4 (detail): With an old sable brush, I begin to lighten portions of the figure selectively. These are generally the lightstruck areas. I also take some color off the fingers on the left hand. I begin to solidify some of the shadows with warm tones. As I pick out color from the head, I begin to refine the shapes and colors. I use the point of the brush to lift some white out of the dark eye socket. I lighten the cheek and the rest of the modeling on the head. Then I add Winsor red and some white to the dark side of the nose, plus a gray wash to the rest of the face and neck. I pick out the light that strikes the top of the right shoulder. I'm a little uneasy about the way that the figure is seated. I want her to be half in repose, half as if she's about to get up. The head doesn't seem right, perhaps because I've altered the pose from the drawing. I don't know what to do yet. Perhaps it will still work out.

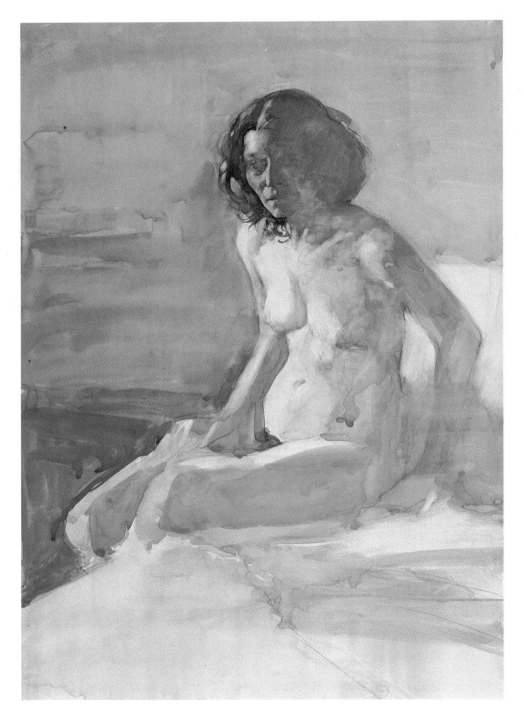

Stage 5: After taking a break for lunch, I look at the painting freshly and I have the feeling that the image is broken up by a lot of small strokes. I also decide that the background needs another layer of color. And that blue-gray wash is still untouched. I add a broader wash to break up that blue area, and I wipe the bedding down to white before tackling the head. I mix a new batch of ochre and white, and then I flood the dark side of the face and neck. Now I add more Payne's gray and white to the hair, so it becomes much darker on the left. I make the eye socket on the left much lighter. I must wait for all this to dry before I know what's going to happen to all these additions. Better take another break.

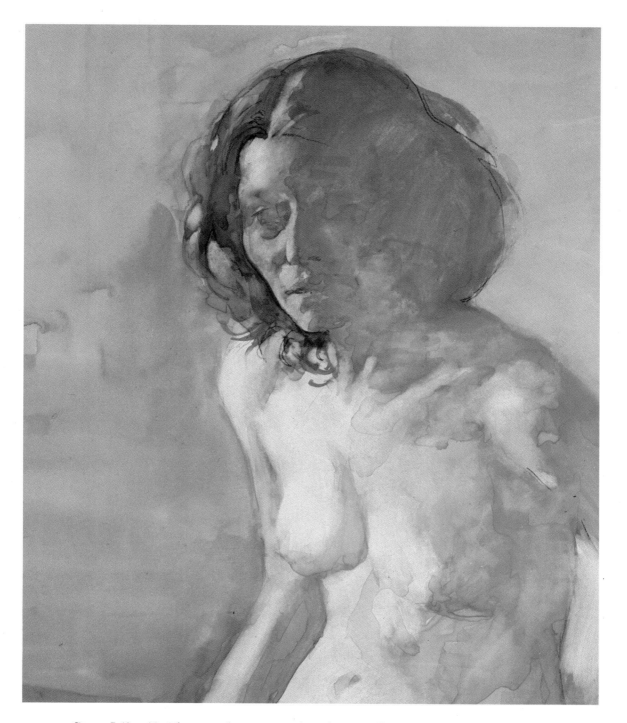

Stage 5 (detail): The new changes are okay, but I realize with some dismay that the head has gotten too large. The funny thing is that this suddenly makes the young woman's body seem more adolescent. An interesting possibility occurs to me. I'll have to adjust this disparity in the drawing, but perhaps I can use this accident to advantage. Maybe I can understate the rendering of the torso to make the body seem more youthful, more fragile. You can see the beginning of that feeling in this closeup.

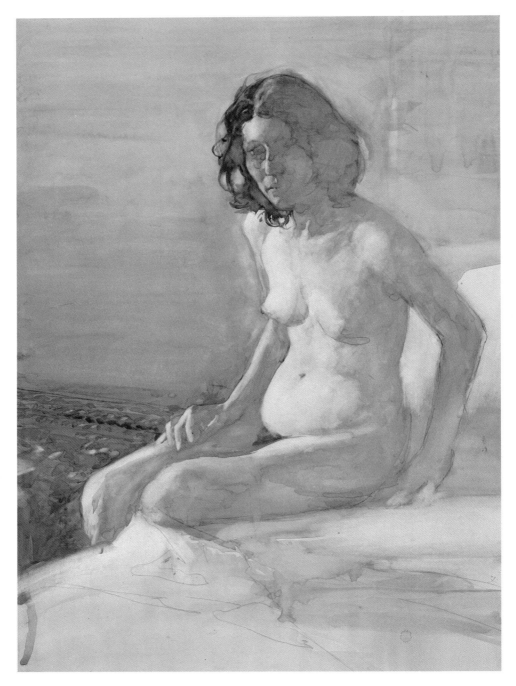

Stage 6: Better not get hung up on the head. So I pursue the rest of the painting more vigorously. I add blobs and patches of color to the floor area at the left to make it look like an Oriental rug. (I'm painting portions of a similar rug that's in my studio.) I begin to model the lower parts of the body. There are new ochre washes on the leg and the right side of the torso. I rub gently with a damp towel to soften the transition of light from the left side to the right side of the body. A pink wash adds form to the breast. I add some vermilion to the hands and let this dry before I redefine the fingers with the wipe-out brush.

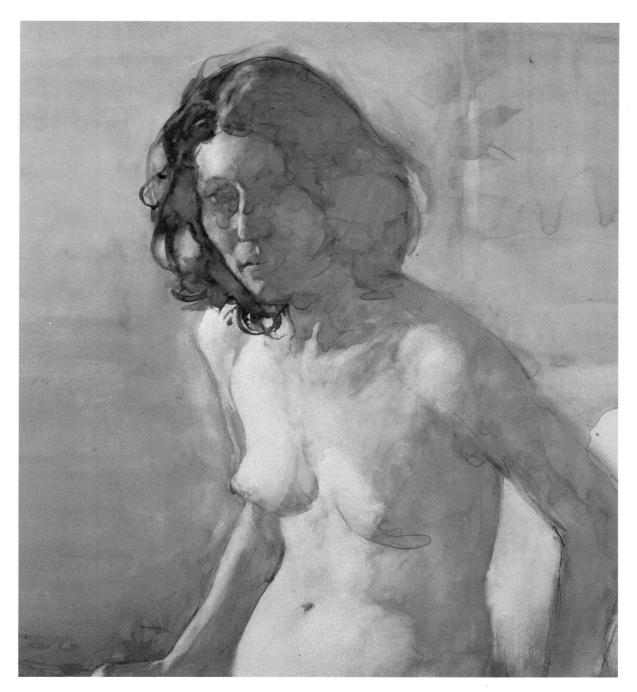

Stage 6 (detail): I rub out some of the background color and repaint it with a grayer wash. In the process, I also cut into the hair mass, wiping out the contour—which looks too massive—and then painting it over as I repaint the background. With repeated wiping and repainting, the paper is beginning to soften up. The new paint isn't as streaky, going on in a more even, slightly blurry fashion, and the color underneath doesn't pick up as much. I mix a wash of golden ochre and vermilion to add definition to the right side of the nose, the eye sockets, and the hair at the top right. I repaint the hair on the left side and cut into the profile, which becomes a bit narrower. I've re-drawn the head, so it now has a slight downward tilt. I think that's better. This is a good time to stop for the day. I'm having trouble seeing the total image. Right now, it just looks like a lot of paint and brushstrokes.

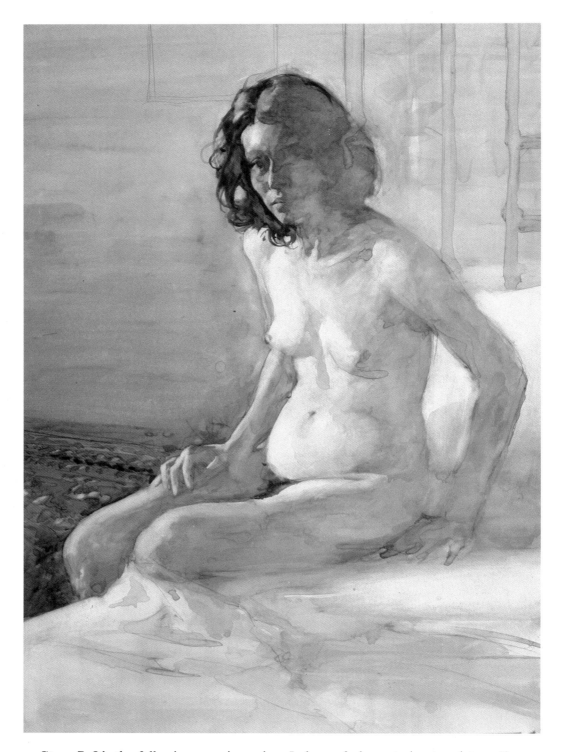

Stage 7: It's the following morning, when I always feel worst about a picture. I'm seeing it freshly and in a different light. The paint always looks a bit different too. I don't know exactly why, but the head doesn't seem right again. I change the proportions of the hair to the face by rubbing the contour slightly, and then doing some more painting. I regret this almost immediately, but I can't go back and change it for the moment. I can't do anything more for a few days, anyhow, since I have other commitments.

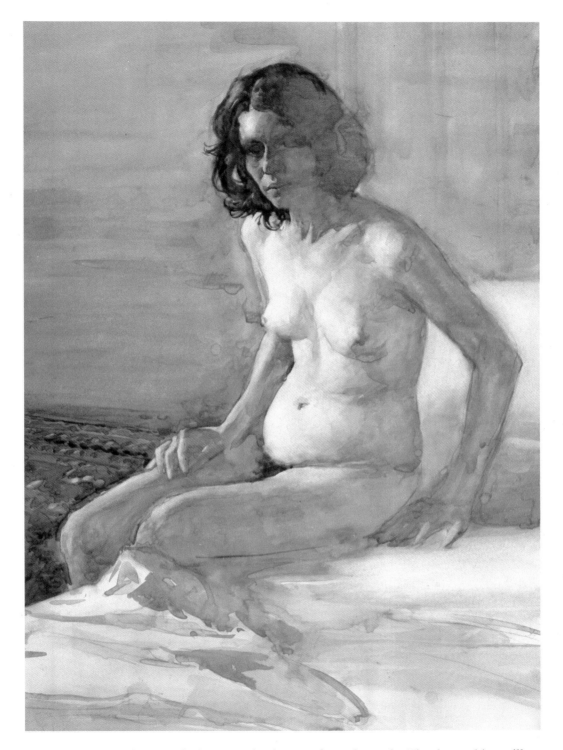

Stage 8: A week passes before I get back to work on the nude. The damn thing still doesn't feel right. I begin to add more details to the head: washes of gray-ochre to the eyes, some more runs of color on the nose. I feel terribly irresolute and the picture begins to depress me. I wonder why I can't translate the original drawing more effectively. As I look at the drawing, it seems more convincing than the painting. I add some more strokes to define the crumpled sheet in the lower part of the painting. The right hand still isn't finished. But *I* am. At least for the moment.

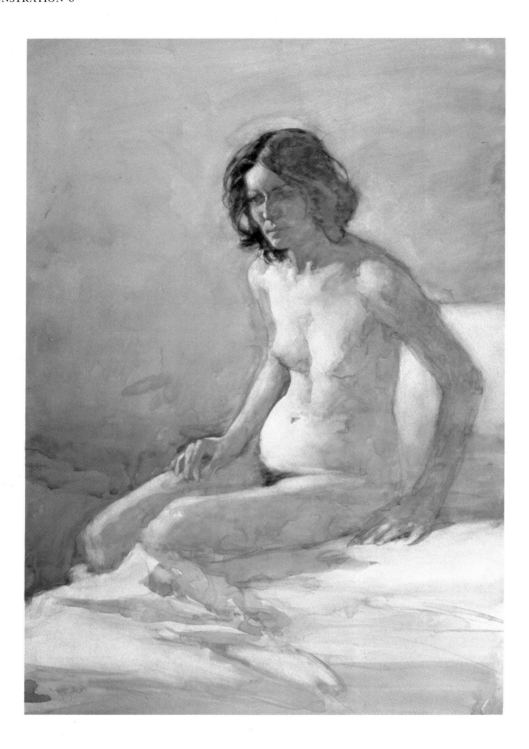

Stage 9: Months go by. I've all but forgotten the picture. But when I pull it out for another look, I feel somewhat encouraged. I like a lot of things about it, and I have the feeling that my original conception is largely realized after all. However, the head still troubles me. The details of the features are far too pronounced. So I rework the head for what seems like the hundredth time! The nose is reshaped and the mouth also has a better shape, although it's softer at the same time. I like the way the eyes melt back into the shadows. I also do some more work on the background, first washing it out and then overlaying the area with a new color. That distracting Oriental rug is gone. It was out of character with the rest of the painting. The warm, simple shape is more effective and less insistent. I also do a bit more wiping on the wall behind the figure, creating a slightly more even tone and modifying the color.

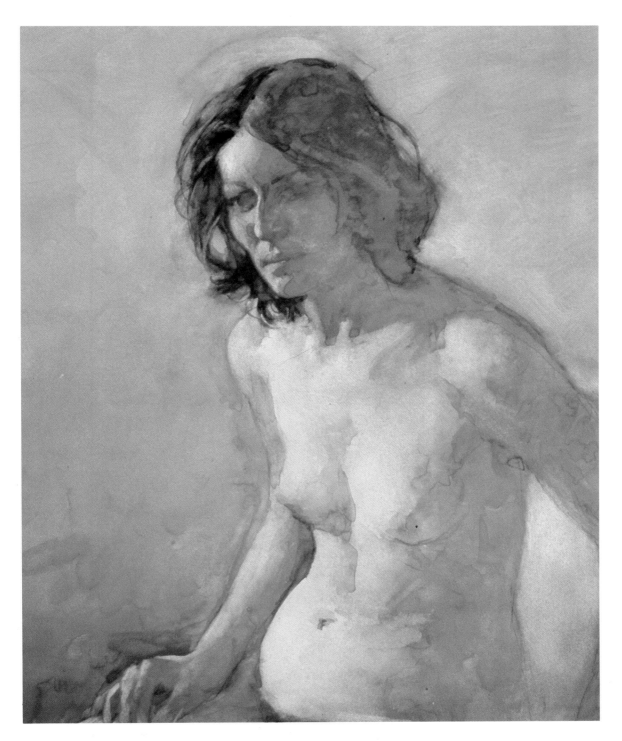

Stage 9 (detail): In this closeup, you can see that I also do some more wiping and modeling on the figure. The paint is smoother and more luminous now. The additional modeling is very subdued, but it makes a difference. I'm less conscious of the paint, more conscious of the form and the action of the light. I'm reasonably satisfied with the way the strongly modeled head contrasts with the much more delicate modeling of the youthful figure. The whole image looks stronger, more generalized. It's interesting to note that the paper has lasted this long, especially in the head, where I've done so many wipings and corrections. *Nude* was finished, at last, in 1982. It measures 13″ x 22″ (33 x 56 cm) and it's done on plate bristol paper.

(right) **I'm a Dancer III,** *1982, watercolor on plate bristol, 22" x 14" (56 x 36 cm), collection of the artist. This is the final painting of a theme that went through a long evolution in my studio, starting with an early series on burlesque dancers in motion and ending with this "portrait" of a topless performer. As I painted this series of pictures over the years, my emphasis gradually shifted from the activity of the performer to a study of the performer as a* person. *The same shift in focus is inherent in my other paintings of the nude.*

(below) **Sleeping Figure,** *1982, watercolor on plate bristol, 14" x 22" (36 x 56 cm), collection of the artist. Like the demonstration painting, this nude was developed from a drawing, not painted from life. Thus, I had to rely on the drawing alone for whatever information I would need for the watercolor. Originally, there was a totally different painting on the surface, which I wiped out completely. The fibers became very frayed, and the paint was extremely difficult to apply. But I persisted in what was a kind of experiment. The finished picture is largely a collection of rubbed and scrubbed areas. I was amazed and delighted to discover how much painting and repainting I could actually do—one more liberating factor in my use of watercolor.*

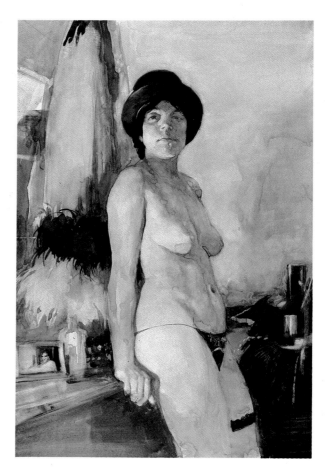

Belly Dancer, *1979 watercolor on plate bristol, 21″ x 9″ (53 x 23 cm), collection of Mr. and Mrs. Sydney Harvey. Posing in my class, the model said that she'd worked as a belly dancer from time to time. I was struck by the fact that her low-key manner seemed so unsuited for the flamboyance of the dance. The painting suggests this contradiction. The model's pose and facial expression seem strangely at odds with her costume. And there's an interesting contrast between the high-key color and the passive pose.*

Index

Edited by Candace Raney
Designed by Jay Anning
Graphic production by Katherine Rosenbloom
Text set in 11-point Times Roman